BASICS

PHOTOGRAPHY

07

EXPOSURE

Ethical: aware-
ness/
reflect-
ion/
debate

a
va
academia

An AVA Book
Published by AVA Publishing SA
Rue des Fontenailles 16
Case Postale
1000 Lausanne 6
Switzerland
Tel: +41 786 005 109
Email: enquiries@avabooks.ch

Distributed by Thames & Hudson (ex-North America)
181a High Holborn
London WC1V 7QX
United Kingdom
Tel: +44 20 7845 5000
Fax: +44 20 7845 5055
Email: sales@thameshudson.co.uk
www.thamesandhudson.com

Distributed in the USA & Canada by:
Ingram Publisher Services Inc.
1 Ingram Blvd.
La Vergne TN 37086
USA
Tel: +1 866 400 5351
Fax: +1 800 838 1149
Email: customer.service@ingrampublisherservices.com

English Language Support Office
AVA Publishing (UK) Ltd.
Tel: +44 1903 204 455
Email: enquiries@avabooks.ch

ISBN 978-2-940411-05-4

10 9 8 7 6 5 4 3 2 1

Design by Gavin Ambrose
Illustrations by David G Präkel

Production by AVA Book Production Pte. Ltd., Singapore
Tel: +65 6334 8173
Fax: +65 6259 9830
Email: production@avabooks.com.sg

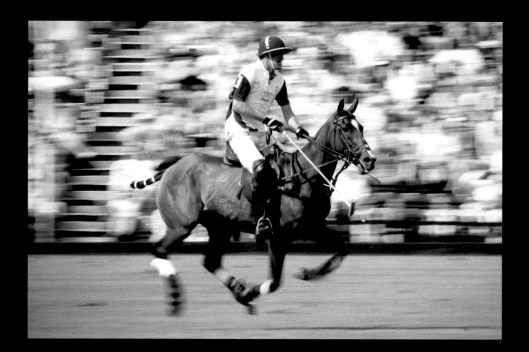

Luke Tomlinson (polo player)

Careful choice of shutter speed and panning keeps the subject crisp while blurring the background to add to the atmosphere. The dynamic blur of the moving hooves – not to mention anticipating when all four feet would be off the ground – shows the power of the shutter and camera movement to depict the dynamic, moving world.

Photographer: Marek Sikora.

Technical summary: Canon EOS 40D Canon 100–400mm L IS USM 1/60 at f/22 ISO 250 Evaluative metering. Tone curve, hue and saturation adjusted in Photoshop.

Contents ▷

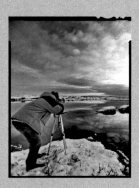

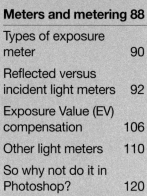

This book covers all aspects of exposure, whether you are using a film or a digital camera. Technical concepts are identified and explained in a straightforward manner on the page through clear diagrams and in a concise glossary. The book is illustrated throughout with creative, thought-provoking images – many taken especially – from contemporary practitioners and classic sources.

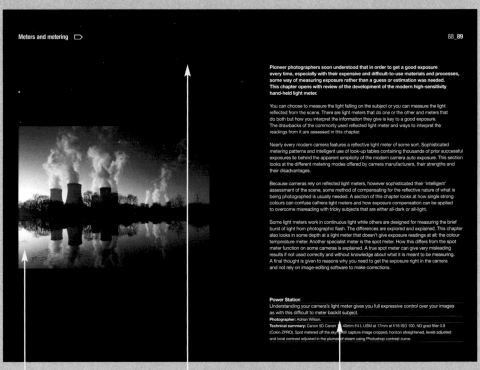

Meters and metering ▷ 88_89

Pioneer photographers soon understood that in order to get a good exposure every time, especially with their expensive and difficult-to-use materials and processes, some way of measuring exposure rather than a guess or estimation was needed. This chapter opens with review of the development of the modern high-sensitivity hand-held light meter.

You can choose to measure the light falling on the subject or you can measure the light reflected from the scene. There are light meters that do one or the other and meters that do both but how you interpret the information they give is key to a good exposure. The drawbacks of the commonly used reflected light meter and ways to interpret the readings from it are assessed in this chapter.

Nearly every modern camera features a reflective light meter of some sort. Sophisticated metering patterns and intelligent use of look-up tables containing thousands of prior successful exposures lie behind the apparent simplicity of the modern camera auto exposure. This section looks at the different metering modes offered by camera manufacturers, their strengths and their disadvantages.

Because cameras rely on reflected light meters, however sophisticated their 'intelligent' assessment of the scene, some method of compensating for the reflective nature of what is being photographed is usually needed. A section of this chapter looks at how single strong colours can confuse camera light meters and how exposure compensation can be applied to overcome misreading with tricky subjects that are either all-dark or all-light.

Some light meters work in continuous light while others are designed for measuring the brief burst of light from photographic flash. The differences are explored and explained. This chapter also looks in some depth at a light meter that doesn't give exposure readings at all: the colour temperature meter. Another specialist meter is the spot meter. How this differs from the spot meter function on some cameras is explained. A true spot meter can give very misleading results if not used correctly and without knowledge about what it is meant to be measuring. A final thought is given to reasons why you need to get the exposure right in the camera and not rely on image-editing software to make corrections.

Power Station
Understanding your camera's light meter gives you full expressive control over your images as with this difficult to meter backlit subject.
Photographer: Adrian Wilson.
Technical summary: Canon 5D Canon 24–40mm f/4 L USM at 17mm at f/16 ISO 100. ND grad filter 0.9 (Cokin ZPRO). Spot metered off the sky. RAW capture image cropped, horizon straightened, levels adjusted and local contrast adjusted in the plumes of steam using Photoshop contrast curve.

Images
All images have been carefully chosen to show only the theory or technique that is being discussed.

Main chapter pages
Special chapter introductions outline the major ideas that will be covered.

Image captions
Captions provide the creative and technical background to the image chosen and give a technical summary of the camera, exposure details and any post-production work.

Headings

Each important concept is shown in the heading at the top of the page, so you can quickly refer to any topic of interest.

Running glossary

Technical terms and phrases are explained on the page they occur.

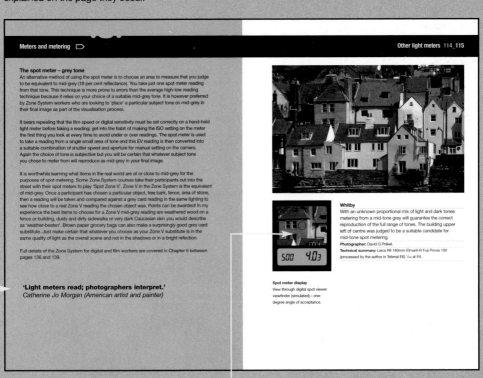

Meters and metering

Other light meters 114_115

The spot meter – grey tone
An alternative method of using the spot meter is to choose an area to measure that you judge to be equivalent to mid-grey (18 per cent reflectance). You take just one spot meter reading from that tone. This technique is more prone to errors than the average high-low reading technique because it relies on your choice of a suitable mid-grey tone. It is however preferred by Zone System workers who are looking to 'place' a particular subject tone on mid-grey in their final image as part of the visualisation process.

It bears repeating that the film speed or digital sensitivity must be set correctly on a hand-held light meter before taking a reading; get into the habit of making the ISO setting on the meter the first thing you look at every time to avoid under or over readings. The spot meter is used to take a reading from a single small area of tone and this EV reading is then converted into a suitable combination of shutter speed and aperture for manual setting on the camera. Again the choice of tone is subjective but you will be certain that whatever subject tone you chose to meter from will reproduce as mid-grey in your final image.

It is worthwhile learning what items in the real world are at or close to mid-grey for the purposes of spot metering. Some Zone System courses take their participants out into the street with their spot meters to play 'Spot Zone V'. Zone V in the Zone System is the equivalent of mid-grey. Once a participant has chosen a particular object, tree bark, fence, area of stone, then a reading will be taken and compared against a grey card reading in the same lighting to see how close to a real Zone V reading the chosen object was. Points can be awarded! In my experience the best items to choose for a Zone V mid-grey reading are weathered wood on a fence or building, dusty and dirty sidewalks or very dark Caucasian skin you would describe as 'weather-beaten'. Brown paper grocery bags can also make a surprisingly good grey card substitute. Just make certain that whatever you choose as your Zone V substitute is in the same quality of light as the overall scene and not in the shadows or in a bright reflection.

Full details of the Zone System for digital and film workers are covered in Chapter 5 between pages 136 and 139.

'Light meters read; photographers interpret.'
Catherine Jo Morgan (American artist and painter)

Whitby
With an unknown proportional mix of light and dark tones metering from a mid-tone grey will guarantee the correct reproduction of the full range of tones. The building upper left of centre was judged to be a suitable candidate for mid-tone spot metering.
Photographer: David G Präkel.
Technical summary: Leica R8 180mm Elmarit-R Fuji Provia 100 (processed by the author in Tetenal E6) 1/125 at f/4.

Spot meter display
View through digital spot viewer viewfinder (simulated) – one-degree angle of acceptance.

Quotations

Specially selected quotes contain the pertinent thoughts of famous photographers, commentators, artists and philosophers.

Diagrams

Screen shots, clear diagrams and concise charts are used to explain and support key technical concepts.

Introduction　▷

Exposure is often seen as one of those annoying things that gets in the way of true photographic creativity. The calculating mindset required to juggle apertures and shutter speeds seems to be at odds with looking at the world, selecting scenes to photograph and reacting intuitively to create great images. It seems far easier to use the increasingly sophisticated automation offered by camera manufacturers (and if the images turn out poorly they can always be fixed later in an image-editing program on the computer). Nothing could be further from the truth.

A poor exposure will rarely lead to a great image. All that the computerised cleverness of the modern camera leads to, in the end, is an exposure combining a selected shutter speed with a selected aperture. The camera's 'scene modes' may be convenient but they are not magic. They reflect an acceptable pre-ordained view of your world. It is not your view. Taking charge of your camera may mean complete manual control or just overseeing its automatic functions. True photographic self-expression is being able to manipulate the photographic variables of shutter speed and aperture to your own ends. Without this control you would not be able to express yourself through the language of photography.

This book explains the basic theory behind making an exposure – what is technically known as sensitometry. It explains how the photographic image is rooted in the effects of controlling light's intensity and duration and asks: 'What is a good exposure?' It then looks at the camera controls that let us manipulate these aspects and the devices we use to measure light energy to establish that 'good' exposure. Every photographic medium (both film and digital) has its limits to record detail in the brightest and darkest parts of the image. No camera 'sees' what our eyes can see – the light meter and an understanding of exposure help us bridge this gap to make memorable, expressive images.

Basic theory

The book opens with an explanation of light itself, its qualities and how light-sensitive materials (both photographic film and sensors) capture and relay its energy.

Shutter speed and time

This section of the book investigates the different types of shutter that control the duration of a photographic exposure.

Aperture and depth of field

Aperture changes the intensity of light passing through the lens and creates different fields of acceptable focus around the plane where the lens is critically focused. This chapter looks at the optical mechanism of this depth of field and how it is used creatively.

Meters and metering

This section looks at the range of light meters that are available, when to rely on your camera exposure meter and when not, as well as techniques for establishing a meter reading for good exposure.

Dynamic range

No photographic image can capture both the shadow and highlight detail seen by the human eye. This chapter investigates the limited dynamic range of every photographic medium (film and digital, colour or black and white) and looks at how best to exploit it.

Special cases

This chapter deals with difficult-to-crack problems, such as white balance, winter photography, close-up photography and flash photography.

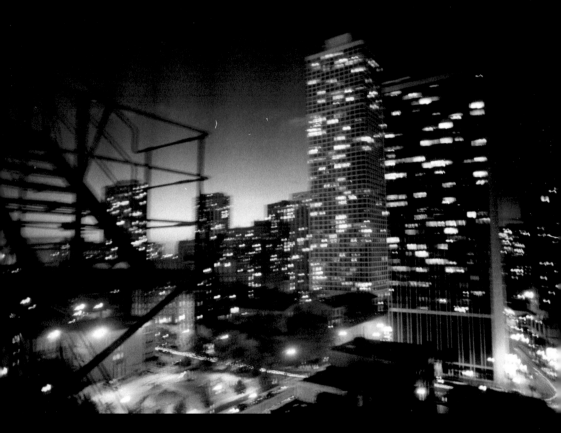

Chicago night

Only with control of all aspects of exposure can photography truly be used expressively. To create the sense of isolation felt by the occupant of a hotel room overlooking a busy city, this image used a long shutter speed to create subject blur, intentional camera blur (and diffusion through a net curtain) plus a knowledge of how to judge a suitable exposure to keep the city twilight looking dark.

Photographer: David G Präkel.

Technical summary: Leica R4 Leica 24mm f/2.8 Elmarit-R hyperfocal focusing 4-5 sec at f/8 Kodachrome 64.

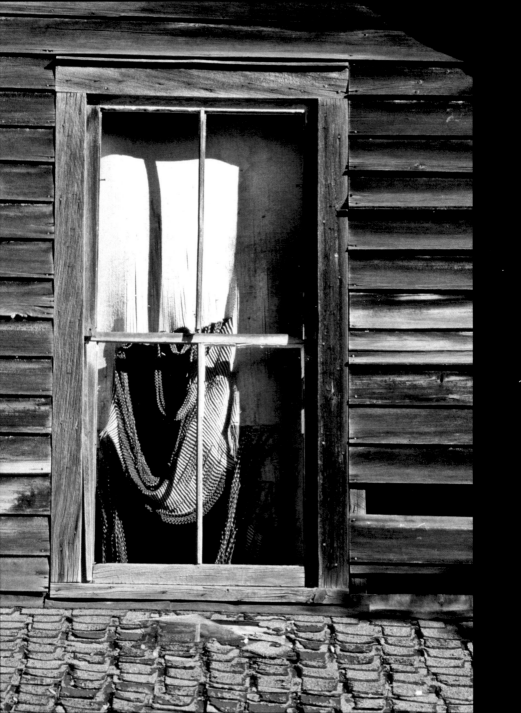

Any book on the topic of photographic exposure has to start where photography starts – with light itself. Light has a particular quality dependent on its source, whether that is a point source or a diffuse source. The angle at which light strikes the subject plays a major part in creating the mood of the final image and can reveal or conceal aspects of the subject such as its form and texture.

Although any light is good light for the black-and-white photographer, those dealing with colour images (with film or digital cameras) have to take into account another aspect: the colour quality of the light. White light – photographic daylight – is not encountered in the real world quite as often as one might expect. The colour of the illuminating light – its white balance – plays a subsidiary role in establishing mood.

Photographers need to quantify light to make sense of both lighting and exposure. This is done using the 'stop', a halving or doubling of light that applies equally to the brightness of the light or the length of time it falls on the film or sensor. The relationship between these two aspects, technically called intensity and duration, is known as reciprocity. This concept lies behind all photographic exposure.

It is also important to understand that some subjects have an inherent contrast (range of tones from black to white) while others may have little or none. The distribution of light itself through the image will influence the reproduction of tones, combined with the subject contrast, which gives the total subject brightness range that has to be captured on film or the digital sensor. Each of these media has it own performance capabilities and limits and these are discussed along with what happens when an image is over- or underexposed in the camera.

Film speed and digital camera sensitivity – that is photosensitivity, the third variable in exposure – are looked at with an eye to the quality issues inherent in high sensitivity and speed. Film can be exposed at something other than the manufacturer's recommended speed. This is looked at in the section on exposure index and the chapter concludes with a look at the use of filters and how to compensate for the light loss they invariably introduce.

Derelict farm, Ovid, NY
Even an apparently simple subject needs thought in order to achieve the right exposure.
To retain detail in the white window blind and leave the interior shadows in complete darkness, a small-area reading was taken from a known mid-tone value: the grey weathered tiles.

Photographer: David G Präkel.

Technical summary: Leica R8 35-70mm Vario-Elmar zoom 1/250 at f/16 Kodak EliteChrome 200.

Light itself

Quality of light

Although exposure primarily concerns itself with amounts of light, it is also important for the photographer to consider the quality of light. 'Dark' or 'bright' might be as far as the average observer gets. The successful photographer, however, needs to be keenly aware of the way in which light interacts with the subject. The commonly used terms 'harsh' and 'soft' concern the quality rather than the quantity of light and are a good way to understand light.

Harsh light is light that has deep, clear shadows and strong highlights. This light itself produces contrast in the subject. Light of this quality is commonly produced by point source lighting as well as focused lighting from spotlights in the studio. Light that seems to play around the subject and fill-in shadow areas to create a much softer effect is called diffuse or soft light. Light of this quality does not come from a small coherent source but from one which is broken up by a diffuser and usually from one or more large sources. A studio soft box or a lit window is a good source of diffuse light.

In the studio, light sources are fitted with light modifiers to control the quality of light – 'honeycombs' placed over a reflector create a unique quality of light that is strong but pooled. Focused spotlights produce a high-contrast look that can be hard to capture and control without some moderating influence of reflected light or a second, more diffuse light source.

Outdoors it is a common mistake to think that sunny days give the best lighting for photography. The sun in a clear sky is itself a point source unique in not obeying the inverse square law (**light fall off**) as it creates strong shadows and highlights and bright reflections. For close-up photography in particular, these conditions are too harsh as small detail will be lost in the contrast and colours will not appear saturated. It is better to work in a shaded area on a bright day.

Light fall off

Light from a point source casts strong shadows away from itself in every direction, producing pronounced highlights and strong shadows. Light radiating from a point source falls away very rapidly – something you experience around the campfire after dark or as you walk with a candle through a darkened room. Two metres away from a point source the light has one quarter its power; just another two metres away the light falls to one sixteenth the power (this is the inverse square law at work, power being equal to one over the square of the distance).

The only point source not subject to the inverse square law is the sun itself. Any distance we move on Earth away from the sun is trivial compared to the distance that the Earth is from the sun.

Light obligingly travels in straight lines so photographers can bounce and reflect it where they want – the quality of the surface off which the light is bounced will affect the quality of the light when it arrives at the subject. A mirrored surface will give a very different quality of light from a flat white surface, for instance.

The quality of light will affect your approach to exposure.

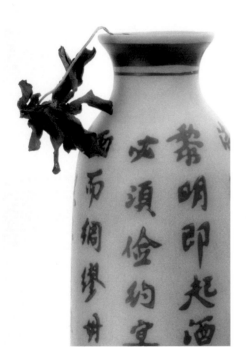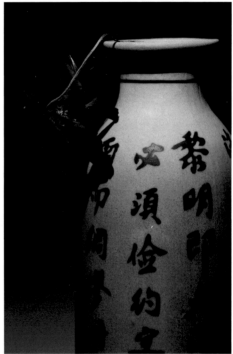

Chinese vase

A subject transformed by two different qualities of light. A light airy mood is created by the diffuse lighting achieved with all-round reflectors and a bare flash head. A second flash and silver reflector was used to the left of the camera. A darker, sombre mood is created by the harsher directional light from the main flash head fitted with a tight snoot.

Photographer: David G Präkel.

Technical summary: Nikon D100 60mm f/2.8D AF Micro Bowens Esprit 500 flash head 1/90 sec at f/22 and f/11 ISO 200.

Direction of light

The direction from which the light falls on the subject has effects both on the large and small scale. It creates a distribution of highlights and shadows that produce the three-dimensional form from what would otherwise be a flatly lit shape. On the small scale the direction that the light falls across the surface of the subject shows up texture or reduces its appearance.

There are different ways to describe the direction from which light falls. This is described in books on studio lighting where it is important to know exactly where the lights were placed to achieve a particular effect. Most use a diagram that places the subject at the centre of an imaginary circle and treats that as a clock face or compass around which the light source or sources are positioned. The camera is usually placed due south or at 6 o'clock. It is sometimes easier just to describe the general directions from which the light falls: front, side and back (light directly from behind) lighting. Light from lamps placed halfway between the camera position and the side lighting position produce three-quarter lighting (camera left or right). This type of lighting produces good shadow and highlight, revealing solid form; side lighting tends to emphasise texture but casts long dramatic shadows that can confuse, especially when cast by a low-angled light source. **Rim lighting** is a special case of back lighting when the light is largely blocked by the subject but enough light spills around the subject to light up the edge or rim.

It is important also to consider the angle of elevation of the light source, be it the sun or a studio lamp. At a latitude of 50°N (London) on the globe, for example, the sun in winter will only be 20–25° above the horizon, rising to 60° in summer. Only at the equator is the sun directly overhead at noon. Where light comes from in an image influences greatly what people read into the image. In a simple portrait, lighting from directly above will give a feeling of summer or the tropics, while lighting from below will introduce an air of the spooky and unnatural. Low-angled lighting is associated with dusk and dawn, also with the seasons of spring and autumn (fall).

Soft, diffuse light strikes the subject from all directions. It fills in any surface imperfection, smoothing and softening the look of textured materials. Strong light from a single direction will emphasise texture, especially when it falls at an angle across the surface of a textured surface. Perpendicular to a textured surface it will minimise the appearance of texture but falling across the surface – 'raking light', as it is described – will emphasise texture. This happens because every high spot is lit with a highlight and every minute low spot traps a shadow. The micro contrast this produces creates a strong appearance of texture.

Rim lighting

A special case of backlighting where light spills around the edge (rim) of the subject from a light source hidden behind or to one side of the subject. Without frontal light this produces a key line around the silhouetted subject; with light from the front, a rim light produces an attractive glowing ring of light around the subject.

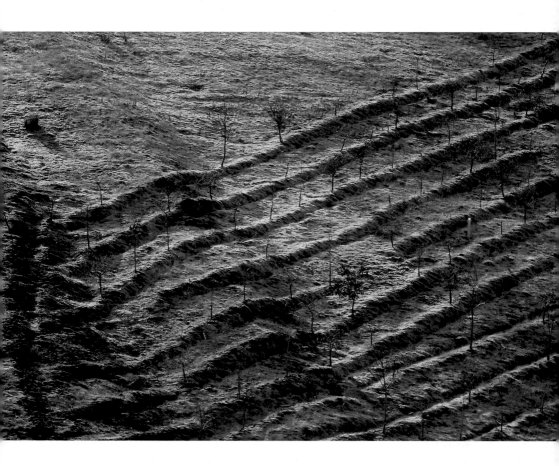

Scarify

Low-level late evening light reveals the terraces made for tree-planting on this sloping hillside.
(From the exhibition New Views; Old Landscapes.)

Photographer: David G Präkel.

Technical summary: Nikon D100 70-300mm f/4-5.6D AF ED Zoom-Nikkor at 145mm (217mm 35mm equivalent)
1/125 at f/4.5 ISO 100.

Colour of light and white balance

We have so far talked about light as if it were neutral white light. The colour of illuminating light is important in photography and an understanding of the colour theory of light is essential. Light is a narrow band of electromagnetic radiation to which the human eye is sensitive. This band has no exact boundaries as sight and perception differ between individuals but typically the human eye is receptive to a range of wavelengths of light between 400 and 700 nanometres (nm). (A nanometre is one millionth of a millimetre.) Between 400 and 700nm lie the familiar colours of the rainbow (red, orange, yellow, green, blue and violet – there is now no indigo as modern science no longer considers it a usefully separate colour). White light contains an even mix of all these colours.

Electro-magnetic spectrum

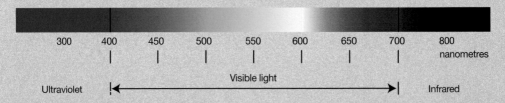

| 300 | 400 | 450 | 500 | 550 | 600 | 650 | 700 | 800 |
| | | | | | | | | nanometres |

Visible light

Ultraviolet |◀━━━━━━━━━━━━━━━━━━━━━━━━━▶| Infrared

There are, however, only three primary colours, which are the colours that are necessary to make up all the others. They are called the additive primary colours (red, green and blue). Equal quantities of red, green and blue light always make a neutral tone, white light if they are bright enough. Black is created by an absence of all colour. RGB is the additive world of light. Without light, there are no colours. A banana only looks yellow if the corresponding wavelengths (colours) are present in the light shining on it. In blue light containing no red or green, a banana looks grey and colourless.

Subtract any one of these additive primary colours – red, green or blue – from white light and the resulting colours will be a combination of the remaining primaries. Cyan, magenta and yellow are the so-called subtractive primaries. Cyan can be thought of as white light less red, magenta as white light less green, and yellow as white light less blue. CMY is the world of reflected light and these colours are used as dyes or pigments in our inks on white paper, or as chemical dyes in film, to act as filters on white light to create the range of visible colours. Add equal quantities of cyan, magenta and yellow inks and theoretically you get black. The dyes have to be very pure to do this and our printing dyes and pigments require the addition of easy to produce black ink to overcome their limitations. Adding cyan, yellow and magenta inks usually produces a purple-brown muddy colour, hence the need for a true black in CMYK four-colour printing.

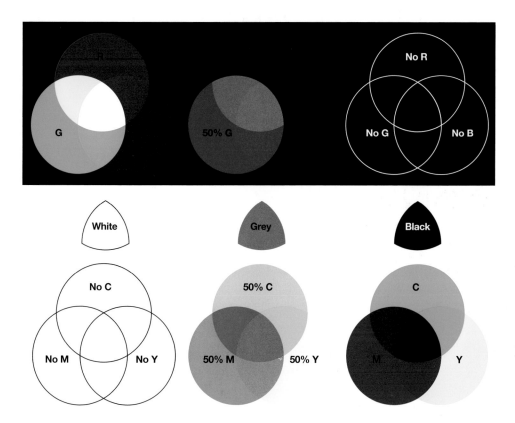

Additive colour (world of light), (top) subtractive colour (world of printing), (bottom)

Photographers map the colours of the spectrum on to a wheel. Red, green and blue are 120° apart on the wheel (at the midday, 4 and 8 o'clock positions). All other colours as combinations of the three primaries lie in between. The colour wheel helps in understanding how to pick colour filters, how to manipulate light and correct for colour casts. The key concept is that opposite colours in the wheel cancel each other. A red filter will darken cyan skies, while a yellow adjustment to an image will correct a blue colour cast. Opposites are known as complementary colours.

Colour wheel

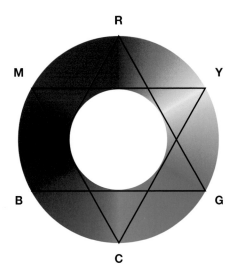

Digital camera hue (colour) adjustments are described as a certain number of degrees that represent a shift in colour around the colour wheel through an arc of that angle. The colour adjustment sliders that confusingly start and end at the same place (cyan, in the case of the Photoshop sliders) are easily explained when seen as being a strip taken from round the edge of the wheel showing every possible colour.

All light is radiant energy and as we have seen, the colour balance of the light that illuminates our photographic scene will affect the colours in that scene. The colour quality of light can be related to its radiant energy on the colour temperature scale. When a black block of iron is heated the colour changes (from dull red, through red, orange, yellow, straw to white-hot) are always the same and relate to specific physical temperatures. The colour temperature scale is a measure of 'whiteness' of light, recorded in Kelvin (using the symbol K, not degrees). The orange-yellow light from oil lights or candles is about 2,000K; photographic daylight is 5,500K, while anything over 7,500K appears blue. Colour temperature can be directly measured by a colour temperature meter, which is covered on pages 116–117.

White balance – in the words of one camera manufacturer – is the job of keeping colours true. It would be hard to find a better description. Each colour in an image can be imagined to be strung out between the neutral tones – when the black and white points are pulled into line all the other colours drop into their proper place. As you click the white and black point eyedroppers on what should be a true black and a true white in an image the colours all seem to come true.

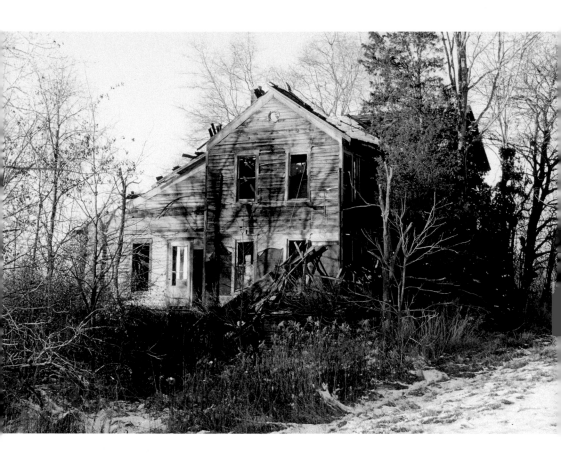

Abandoned farm near Seneca, NY

There are times to let the colour balance be technically wrong for subjective reasons – filtering this scene to achieve a neutral white balance would destroy the magically golden light.

Photographer: David G Präkel.

Technical summary: Leica R4 35-70mm Vario-Elmar zoom exposure not recorded Kodak EliteChrome ExtraColor 100.

What is a good exposure?

There can be two answers to the question 'what is a good exposure?' The first answer is the exposure that is technically correct. The second answer is what feels right to the photographer and looks right in the final print. The easiest approach is to get the exposure technically correct first. If you can confidently do this it will then give you a baseline for further adjustments that are subjectively rather than objectively based.

So technically speaking what is a good exposure? First we must presume that the subject to be photographed has a full range of tones (that is, it is not predominantly dark or light), then that it has a subject brightness range (SBR) (see pages 34–37) not exceeding the capabilities of the chosen photographic medium. Given those conditions, a good exposure will be one that shows detail into the darkest shadows and detail into the brightest highlights. For a normal contrast subject it will show an even distribution of tones, not a rapid change from dark to light nor a skewed look with mid and dark tones only or mid and light tones only.

A technically correct exposure may not be what you are looking for but it is the place to start. Subjectively speaking a good exposure is one that does its job and hits the emotional spot. This is when you adjust the technically correct exposure to suit your taste. With a subject that has a wide SBR, adjusting exposure up or down will result in lost detail in either highlights or shadows. These are described as blown-out highlights and blocked-up shadows. With scenes having five or fewer stops SBR, it is possible to intentionally under- or overexpose the scene by one stop to lighten or darken the look of the image without losing information. Adjusting aperture would change the depth of field, so if it is possible, use shutter speeds to make any subjective change.

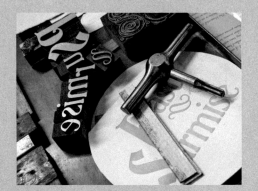

Letterpress printing

A hand-held image taken in a print studio – good exposure gives good highlight and shadow detail, and appropriate white balance. This was obtained by choosing a suitable sensitivity to ensure shake-free shutter speed and sufficient depth of field (helped by image stabilisation and small format respectively). A histogram was also used to establish the final exposure.

Photographer: David G Präkel.

Technical summary: Canon G9 14.8mm (60mm 35mm equivalent) 1/25 at f/3.2 White balance Fluorescent ISO 400.

If you do get it wrong, remember the medium you are using. An overexposed negative is not a disaster but an underexposed negative will have no usable shadow detail. Do not underexpose negative film. An overexposed transparency (slide film) or digital image is a disaster, as lost highlight detail cannot be recovered. An underexposed transparency will be too dark but an underexposed digital image can be recovered (especially if it was captured using the RAW file format). It may end up with more noise than you wanted but there will be recoverable shadow detail. Do not overexpose digital images. As for transparencies – you really do have to get the exposure on the nail, as there is so little latitude.

Monroe Avenue (negative and print)

A good negative with shadow and highlight detail of a subject with a full tonal range may appear quite flat or less dense than you expect. Clear edge markings show correct development while deep shadows are the same tone as the film base and highlights are not too dense.

Photographer: David G Präkel.

Technical summary: Bronica RF645 45mm f/4 1/250 at f/16–22 Fuji 400 developed in Kodak D-76.

Histograms

Modern digital cameras have built-in exposure meters and can display the distribution of tones in the image with a bar chart (histogram) that shows how many pixels there are in each tonal range. This helpful display can be used as a means of understanding tonality, contrast and exposure.

A histogram is a simple bar chart that displays the numbers of pixels in each colour intensity level. The histogram usually depicts 256 levels of brightness from 0 to 255 where black is 0, mid-grey is at 128 and white is level 255. White is to the right of the graph, with all the light tones to the right and all the dark tones to the left. The histogram can be confusing if you do not fully understand what it shows. The best analogy is to think of it as a stock control chart for pixels and that the image is a warehouse full of pixels of 256 different types. To know what your warehouse contains at any one time you would need to count up how many pixels you have of each different type (brightness). Charting these with the low-value dark pixels to the left and the high-value light pixels to the right makes up a histogram.

On some cameras the histogram is divided into the 'safe' five-stop range, on others the quarter and three-quarter tones are marked. More advanced cameras can display the levels in each of the red, green and blue channels independently. This is helpful to show when the information is clipped (cut off). In all these displays the vertical height is not important as the category with the biggest pixel count is made to fit the maximum vertical height on the display.

There is no such thing as a perfect histogram. Its shape depends entirely on what is in front of the camera. Histograms are particularly useful in showing any lost information in shadows or highlights, where the chart ramps up towards black or white and clips the information. A histogram gives a good indication therefore of the image 'key' with a low-key image showing a left-skewed distribution of data and a high-key image showing a right-skewed chart. See pages 102–103 for more information on using the digital camera histogram as a light meter.

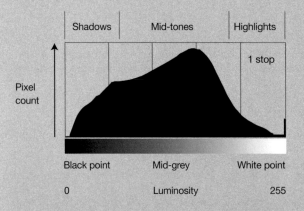

Pixel count

Shadows | Mid-tones | Highlights

1 stop

Black point | Mid-grey | White point

0 | Luminosity | 255

Histograms
A histogram displays the number of pixels in each colour intensity level.

Black, mid-grey, white, mixed black-and-white and colour subjects with their histograms

Black

Left biased chart.

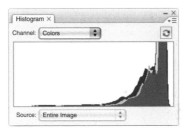

Grey

Generally centred chart.

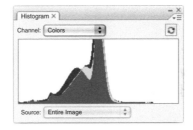

White

Right biased chart.

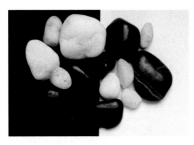
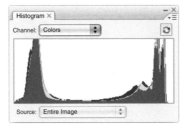

Black and white

'Twin Peaks'.

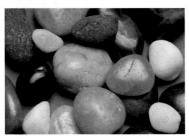
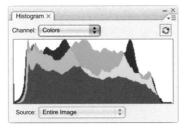

Colour

Good overall distribution with discrete peaks of colour.

Contrast

Contrast is the term used to describe the perceived difference between the dark and light parts of an image. A high-contrast image will consist mainly of darker tones and light tones; a low-contrast image will be made up mainly of mid-tones and will not show the tonal extremes of a high-contrast image. An image with normal contrast will have a regular distribution of tones from dark through mid-tones to highlight tone. Contrast can also be thought of as the rate of change of tones from dark to light – something that will be discussed in the next section in the context of contrast curves.

Contrast in a digital image is adjusted either through the Levels dialogue box or by using a Tone Curve. Adjustment with the Levels dialogue offers only black, white and mid-point adjustments in Photoshop, though the interactive levels histogram in Photoshop Lightroom now has four regions labelled Exposure, Recovery, Fill Light and Blacks, making the adjustment of contrast much easier and much more controllable. The Curve adjustment is capable of far finer control over smaller ranges of tone – up to 16 with current editions of Photoshop.

For the film user, contrast in the negative can only be altered by the choice of developer or by under- or overexposing the film and consequently over- or underdeveloping it. Full details of how film contrast can be manipulated are given in the section relating to Exposure Index on page 52 and in the section on pushing and pulling film on page 140.

'I photograph anything that can be exposed to light.'
Imogen Cunningham (American photographer)

Low-, normal- and high-contrast versions of the same image

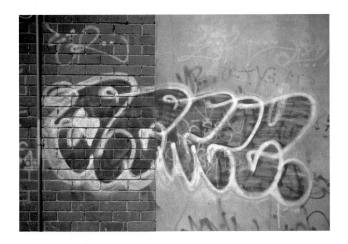

Low contrast
The low-contrast image has a very centred histogram showing only mid-tones.

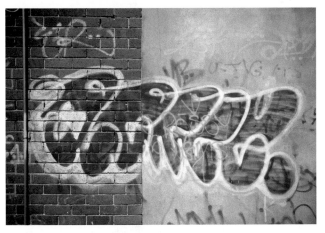

Normal contrast
The normal-contrast image has a fairly balanced shape.

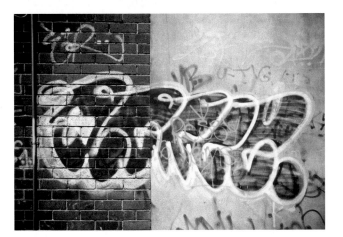

High contrast
The high-contrast image shows the beginnings of the classic high-contrast U-shape.

Waterhouse stops

A set of six Waterhouse stops dating from the late nineteenth century (originally supplied by Andrew Ross & Co., Opticians, London) showing the progressive change in aperture. An appropriate stop was inserted into the light path through a slot in the side of the lens barrel.

Stops

Photographers use the expression 'stop' when referring to changes in exposure. It is a very useful concept, as it does not specifically relate to aperture settings or shutter speeds on the camera. One stop is simply a halving or doubling of light – it is a relative and not an absolute term. Halve the light and you reduce it by one stop. Conversely, double the light and you increase it by one stop.

'Stop' is actually a historical term and is most clearly associated with so-called Waterhouse stops. Early photographers were grateful for all the light their lenses passed, so insensitive were the materials in use. As photosensitive materials became just that – more sensitive to light – photographers began to need a way of controlling the intensity of light coming through the camera lens. They could always adjust the overall exposure by changing the time the photographic material was exposed in the camera but being in control of the intensity of light through the lens as well gave more flexibility.

The Waterhouse stop was named after John Waterhouse, who invented these circular holes in thin strips of metal in 1858. They were called stops because they stopped some of the light passing through the lens. Waterhouse stops were produced with a range of different circular holes. The diameter of each hole let through twice as much light as the previous stop in the series. A separate stop was required for each setting and was fitted into a slit in the lens body.

For greater convenience a rotating disc with circular holes of various diameters was fitted to some lenses. The adjustable metal-bladed iris familiar in today's lens was the most modern way to adjust the brightness of the light the lens passed. The hole in the iris was known as the aperture. An adjustable iris gives infinite control over the light passing through the lens to the film but to retain the halving and doubling relations the appropriate settings were marked against the adjuster on the lens body. Later a click mechanism was built into the mechanical aperture ring. The electronic control wheel on the modern digital camera supersedes this today. It is still controlling a multi-bladed iris deep within the lens, though motors nowadays activate this.

The intensity of light that passes through a stop is directly related to the area of the circle and not simply its diameter, which helps explain the mathematical sequence of the f-numbers used to denote lens aperture. There is more important information on the stop on page 33 and in the section on f-numbers and stops on pages 74–77.

Reciprocity

The idea of reciprocity is the key to all photographic exposure but the mere word is enough to put many people off. To make an image you have to expose something that is sensitive to light energy to light in a controlled manner. The photosensitive material – film is easiest to understand initially – is something that becomes dark when exposed to light. The more light, the darker the material goes. But when someone says 'exposed to light' what exactly do they mean?

The simplest analogy is that of making toast. There are – roughly speaking – two ways of achieving a perfectly browned piece of toast. If you are toasting your bread under an electric grill you can set the grill to a high setting. Your toast will be done to brown perfection quickly. Alternatively, you could set the grill to a low setting – you would have to wait longer but eventually you would have an identical piece of perfectly browned toast. Substitute film (or a digital sensor) for the toast and light for heat and you already understand reciprocity.

Ignoring the sensitivity of the photosensitive film or sensor for the moment, you have, as a photographer, a certain amount of light energy available to make your exposure. It is up to you how you divide this up. The lens aperture gives you control over how bright the light is, while the shutter and shutter speed control give you control of how long the light falls inside the camera. You therefore have intensity of light and duration as the two variables. To maintain a constant quality of image – a good exposure in other words – you need to adjust the duration relative to the intensity. If you open the aperture and increase the intensity then you must reduce the duration. Conversely, if you reduce intensity by making the aperture smaller you must increase the duration to keep the same exposure. This relationship between aperture and shutter speed is the key to understanding exposure.

The combination of aperture and shutter speed determines how much light reaches the film or sensor. Increase intensity and reduce duration; reduce intensity and increase duration. The two variables are being used against each other to maintain a balance. More of one, less of the other – this kind of relationship is known as reciprocal. Technically, this means their relationship is inversely correspondent but think of it as give and take. This is the Law of Reciprocity, which states that, within normal sensitivity limits, exposure = intensity x duration.

Aperture	Shutter speed	
less light f/32	*more time* 1	
f/22	2	
f/16	4	
f/11	8	
f/8	15	
f/5.6	30	
f/4	60	
f/2.8	125	
f/2	250	
f/1.4	500	
f/1 *more light*	1000 *less time*	

Each step halves
↕
Each step doubles

Each step doubles
↕
Each step halves

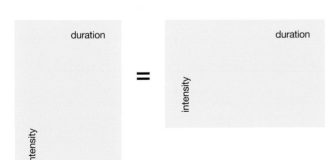

duration = duration

intensity

intensity

Reciprocal relationships

Once the reciprocal relationship between f-stop and shutter speed is established combinations of f-stop and shutter speed will give an equivalent exposure. So, for example: 1/30 sec at f/5.6 is the same as 1/60 sec at f/4 is the same as 1/125 sec at f/2.8 is the same as 1/250 sec at f/2 and so on. (The diagram is an example only and relates to aperture and shutter speed combinations for a light meter reading of EV10.)

Exposure Value (EV)

Master photo-technician and landscape photographer Ansel Adams first referred to light value numbers (LV) in his 1948 Zone System articles – this universal scale was quickly adopted by Polaroid, for whom Adams worked as a consultant. The advantage of such a system is that all combinations of lens openings and shutter speeds that give the same exposure are represented by a single number. With their reflected light meter marked in LV numbers, and a single dial on the camera that set both shutter and aperture, Polaroid offered a simple-to-use yet flexible exposure system for the general public.

The exposure value (EV) system is a development of the LV system but takes into account film speed (or digital sensitivity). It too is a method of stating exposure settings by using a single number instead of the traditional combination of f-stops and shutter speeds. EV0 is an exposure of one second at f/1.0 (or any equivalent combination) with ISO 100 sensitivity.

The single EV number reading from a professional hand-held meter is a good way to start thinking about exposure in the manner it should be approached. Take a reading – say it is EV10. This is the amount of light energy you have to play with – if you have already chosen your ISO film speed or sensitivity you can use the EV10 number to think about any reciprocal combination of shutter speed and aperture.

Maybe you want to use a wide aperture of say f/2.8 to have a limited depth of field, picking out just the subject sharply from a blurred background; EV10 tells you the shutter speed needs to be 1/125 sec. Alternatively, you may want to emphasise movement and create subject motion blur by using a longer shutter speed of say 1/2 sec – the same EV10 reading then tells you that you will need an aperture of f/22 to achieve the longer shutter speed. Having that EV number first doesn't pin your mind to a specific photographic approach. It lets you consider the amount of light you have relative to your film speed or chosen digital ISO sensitivity, then encourages you to decide how to divide up that energy between intensity and duration.

EV numbers give you a good indication of how well a camera or hand-held light meter performs. Can your meter give you a reading with slow-speed film in dark conditions? Where does it fail to give a reading? Check the specifications with the camera or meter and under the heading Metering range you will find the sensitivity range given in EV numbers. A top-of-the-range professional camera will commonly give EV0 to EV20 (ISO 100) with evaluative metering but only EV2 to EV20 with spot metering. A modern hand-held meter will better this range – one example giving EV1 to EV24 in spot metering mode and a massive EV2 to EV23 in 'incident mode' (see page 92). The camera meter EV range should also be accompanied by information about the speed (maximum aperture) of the lens fitted to the camera to achieve these results. A slow lens with a small maximum aperture will not permit the same sensitivity in darker conditions.

Common Exposure Values (ISO 100)

EV5	Scene lit by the full moon
EV5–7	Domestic interiors
EV7–8	Industrial (well lit) and office (artificial lighting) interiors
EV8	Bright street scenes at night
EV8–9	Sports arena (illuminated area, not the crowd)
EV9–12	Dusk
EV10–12	Overcast days
EV13	Bright but cloudy day with no shadows
EV14	Hazy sunshine with soft shadows cast
EV15–16	Full sun with clear shadows cast
EV17	White object in full bright sunshine
EV18	Bright highlight reflection of sun

EV – Exposure Values (ISO 100)

	f-number												
shutter (s)	1	1.4	2	2.8	4	5.6	8	11	16	22	32	45	64
60	-6	-5	-4	-3	-2	-1	0	1	2	3	4	5	6
30	-5	-4	-3	-2	-1	0	1	2	3	4	5	6	7
15	-4	-3	-2	-1	0	1	2	3	4	5	6	7	8
8	-3	-2	-1	0	1	2	3	4	5	6	7	8	9
4	-2	-1	0	1	2	3	4	5	6	7	8	9	10
2	-1	0	1	2	3	4	5	6	7	8	9	10	11
1	0	1	2	3	4	5	6	7	8	9	10	11	12
1/2	1	2	3	4	5	6	7	8	9	10	11	12	13
1/4	2	3	4	5	6	7	8	9	10	11	12	13	14
1/8	3	4	5	6	7	8	9	10	11	12	13	14	15
1/15	4	5	6	7	8	9	10	11	12	13	14	15	16
1/30	5	6	7	8	9	10	11	12	13	14	15	16	17
1/60	6	7	8	9	10	11	12	13	14	15	16	17	18
1/125	7	8	9	10	11	12	13	14	15	16	17	18	19
1/250	8	9	10	11	12	13	14	15	16	17	18	19	20
1/500	9	10	11	12	13	14	15	16	17	18	19	20	21
1/1000	10	11	12	13	14	15	16	17	18	19	20	21	22
1/2000	11	12	13	14	15	16	17	18	19	20	21	22	23
1/4000	12	13	14	15	16	17	18	19	20	21	22	23	24
1/8000	13	14	15	16	17	18	19	20	21	22	23	24	25

Reverse graffiti

Image comprised entirely of pressure-cleaned and dirty areas on subject reflecting different amounts of light. Flatly lit, the image comes solely from subject contrast.

Photographer: Mara Ambrose.

Technical summary: Canon EOS-1D Mark II N Canon 50mm EF f/1.4 USM 1/40 at f/4.5 ISO 100.

Walking on shadows

Image comprised entirely of light and dark patches on a plain surface that has no subject contrast. Image comes solely from lighting contrast.

Photographer: David J Nightingale.

Technical summary: Canon EOS 20D Canon 17–40mm f/4 L USM at 17mm (27mm 35mm equivalent) 1/400 at f/6.3 ISO 100.

Subject contrast is the difference between the lightest and darkest tones in an evenly lit subject. It is the difference between the amounts of light that are reflected back by the different materials that make up the subject. A subject consisting of a single tone has no subject contrast. In even lighting, real-world subjects show a variety of tones depending on colour and texture – the luminance of each part of the subject. Subject contrast is commonly expressed as a ratio or as a range of a number of stops.

It is easy to assess subject contrast with a reflected light meter. The classic example given is of a model wearing black trousers and a white shirt in flat (even) lighting. It is easiest to work with a meter set to read EV numbers. Typical readings would show a 6EV difference between the black and white tones on this subject. This is a six-stop range (1EV = one stop), which gives a subject contrast of 64:1, referring to the table below.

Lighting ratio

one stop = 2:1 (less than this is low contrast)
two stops = 4:1
three stops = 8:1
four stops = 16:1
five stops = 32:1 (greater than this can be considered high contrast)
six stops = 64:1
seven stops = 128:1 (contrast of the average outdoor scene)
eight stops = 256:1

In the dark, a subject has no contrast. Without light there are no tones or colours at all. Things become interesting when the lighting is not even – when bright light falls on one part of the subject and casts shadows on other parts. (Graduated lighting is what produces modelling, from our understanding of the fall of highlights and shadows and the reflective qualities of the subject's surfaces.) Imagine for a moment our subject has changed into a mid-toned grey sweater and trousers; subject contrast would drop to zero. But shine a bright light on his body – but not his legs – and the luminance of that part of the subject goes up, the shadowed part goes down. In the studio a main or key light will be used to set an overall look or mood while a fill light will allow some detail to show in the shadow areas. The ratio of these lights is called the lighting ratio.

It is important for studio photographers – especially portrait photographers – to be able to measure and control the lighting ratio. Some light meters will directly measure the lighting ratio. Some meters have a swivelling head to more easily measure light coming from two different sources and are used with a flat diffuser pointed directly at the lights. The display will show the number of stops difference between the two light sources, which you can then interpret as a lighting ratio from the table above.

Subject Brightness Range (SBR)

When the subject is evenly lit, the subject contrast range will equal the **reflectance** of the lightest and darkest tones. As we have seen, a change in illuminating one part of an evenly toned subject and not another can produce a range of **luminances**. What you end up photographing in the real world is a combination of the inherent subject contrast and the lighting contrast – this is known as the subject brightness range – sometimes referred to as just SBR – and is the all-important consideration for the photographer.

subject brightness range = subject contrast x lighting ratio

If a subject with a contrast range of 32:1 (five stops) is illuminated by lights with a ratio of 2:1 (one stop) then the overall subject brightness range will turn out to be 64:1. While a digital and black-and-white film camera will have no difficulty with that subject, it is already beginning to exceed the range capable of being recorded on transparency film. If you were using that medium you would have to adopt some strategy to reduce the SBR if you wanted to get both good shadow and good highlight detail. Changing the lighting contrast can be done either by using different light sources of different intensities or by setting two identical lamps at different distances from the subject (remember the inverse square law). Photographers working in the field have to cope with whatever SBR Mother Nature throws at them. They learn to wait for the weather and light to change to produce more amenable lighting.

Measuring SBR is simple. Though it is not presented as such, the high-low spot metering technique discussed on pages 112–113 measures the contrast ratio, the dynamic range in stops – this is the subject brightness range. If you are using a camera with a small area metering function, switch to that and with the camera in manual mode take a light meter reading from the brightest area. Note it down. Now take a reading from the darkest area by adjusting either the shutter speed or the aperture but not both. You can work out the number of stops between the two readings and that is your SBR. For example: you meter the brightest area in your image at 1/250 at f/11 and to get a centred meter reading in the dark area you now need to adjust the aperture to f/2.8 – f/11 to f/8 to f/5.6 to f/4 to f/2.8 is four stops (a 16:1 SBR).

Reflectance
Measure of the proportion of light falling on a surface that is reflected (see also grey card).

Luminance
Measure of luminous intensity per unit area of light; describes the amount of light emitted (or reflected) from a particular area (technically defined as that falling within a solid angle). In less technical terms, a measure of how bright the surface will be perceived by the human eye.

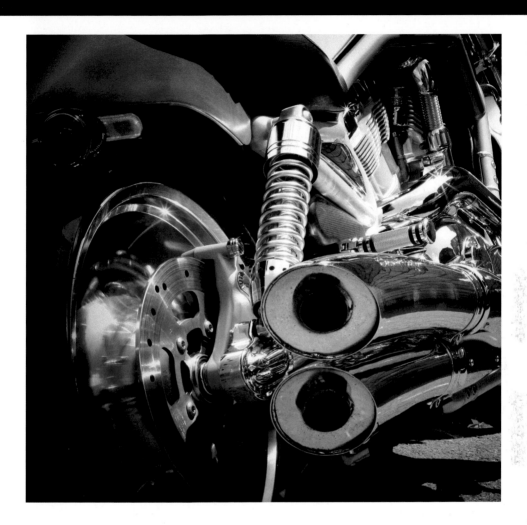

Harley

Strong sun and deep shadows on black rubber and bright chrome give a massive subject brightness range. Exposure in the middle of the range may lose the extreme details in highlights and shadows but gives a natural look.

Photographer: John Green.

Original exposure details: Canon 350D Canon 50mm EF F/1.4 USM 1/60 at f/20 ISO 400.

Latitude (film) and dynamic range (digital)
We expect our cameras to have the same vision as our own – to 'see' and record the same things as our eyes do. In reality they offer a much more limited dynamic range. Human vision is a complex system with both optical and neurological components. At any given moment we can perceive a brightness range of somewhere between 10 and 14 stops (better than 1,000:1 and less than 20,000:1). From extreme dark to extreme light we can probably perceive a total range of 2,000,000:1.

Film and digital sensors are both limited in the subject brightness range they can handle. Colour transparencies can only accommodate a five-stop range, which represents a brightness range of only 32:1. Black-and-white and colour negative films have a seven-stop range. This represents a brightness range of 128:1. It should come as no surprise that if you take a full-toned gloss black-and-white print and measure the highlight to dense black range with a reflection densitometer you will get something very close to 128:1. Black-and-white film and photographic paper are literally made for each other.

Digital RAW files have greater latitude than JPEGs and now can better black-and-white and colour negatives at 10–12 stops. Some sensors offer a theoretical near 14-bit performance but there are plenty of optical issues – notably flare in lenses – that reduces this performance.

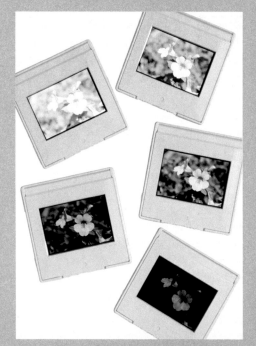

Bracketing (film)
A set of five transparencies on a lightbox showing bracketing at one-stop intervals.
Photographer: David G Präkel.
Original exposure details: Leica R8 100mm APO-Macro Elmarit f/2.8, Kodak EliteChrome. 100ED 1/60 (+2EV), 1/125 (+1EV), 1/250 (metered), 1/500 (-1EV) and 1/1000 (-2EV) at f/8.

Latitude is a related idea. It is a report in terms of the number of stops of over- or under-exposure that film can handle (+1.5 and -0.7, for example). Negative films have greater latitude than positive reversal film.

It is vital that lighting and exposure take into account the latitude or dynamic range of the chosen photographic medium. It is as important to learn how the camera 'sees' the world and work to express your own vision through the limitations of the medium. If the dynamic range of the original exceeds the latitude of the medium then the photographer might have to consider re-lighting the scene or accept a compromise in whether highlight or shadow details will be lost.

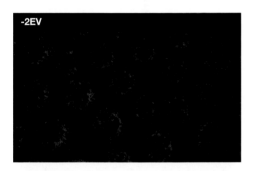

-2EV

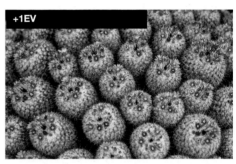

+1EV

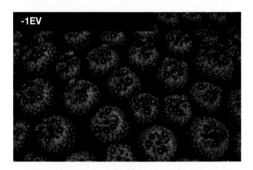

-1EV

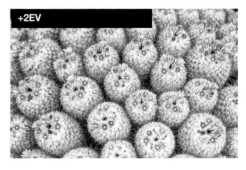

+2EV

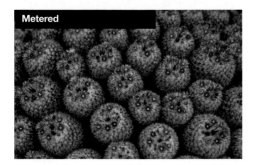

Metered

Bracketing (digital)

Flowering cacti bracketed at one-stop intervals – five exposures. Though the middle exposure in the sequence was technically correct, the +1EV image is a better subjective choice.

Photographer: David G Präkel.

Technical summary: Nikon D100 60mm f/2.8D AF Micro 1/60 at f/3.3 (metered) ±2EV ISO 200.

Over- and underexposure

Overexposure

Overexposure happens when there is too much light for a good exposure. There are a good number of reasons for overexposure to happen. The lens aperture could have been set too wide (or on a studio camera left fully open for critical focusing and not stopped down to the taking aperture). The selected shutter speed could be too long. Alternatively the film speed was incorrectly set too low for the film loaded in the camera.

With digital cameras and transparency films the result of overexposure is a thin, pale washed-out final image. Highlight detail will be completely absent and areas that should have contained detail from the brighter parts of the subject will show as a completely white hole. Such highlights are described as being 'blown out'. There is no adjustment or editing that can be done to recover the lost data from blown-out highlights. If the problem is slight and it does not affect large parts of the image it is sometimes possible to substitute a light tone of four to five per cent grey into the blown-out highlights. This can be done with the Output slider in the Levels dialogue – see pages 44–45 for further details.

With negative film, overexposure will produce a very dark, thick-looking image. If you need to distinguish overexposure from **overdevelopment** this can be done fairly easily by looking at the density and appearance of the film negative edge markings. These are put on the film stock during manufacture in a controlled manner; with overdevelopment the edge markings will show dark and smudged. If they appear clean and normal the fact that the image is dark is due to overexposure not overdevelopment. Overexposure is far less an issue with negative film as all information may well have been captured on the negative (unless the overexposure was gross). Choice of printing paper contrast and increased exposure time in enlarging can often produce a normal print from even badly overexposed negatives. This most certainly is not the case with transparency film or digital cameras where overexposure is to be avoided.

Intentional overexposure can produce fascinating results where light seems to etch the coloured image. An overexposed image can be dramatically improved by mid-tone adjustment – a technique that finds favour with some fashion photographers.

Overdevelopment

To exceed the recommended development – film left in developer for too long, with developer that is too strong or too hot. Beyond increased (N+1 and N+2) development.

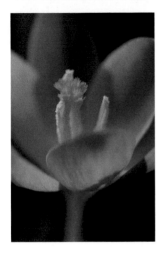

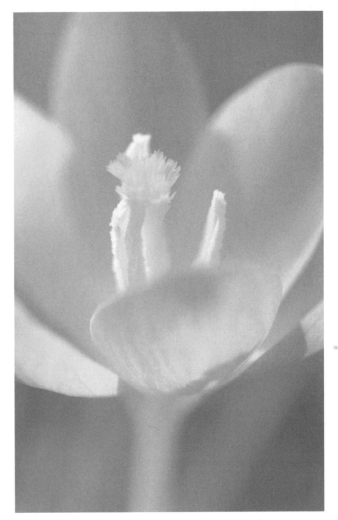

Crocus

Deliberate overexposure of 2 1/3 stops produces pastel shades in keeping with the shallow depth of field and soft focus quality. The thumbnail shows the metered exposure.

Photographer: David G Präkel.

Technical summary: Nikon D100 60mm f/2.8D AF Micro 1/80 at f/6.7 (metered at 1/200 at f6.7) ISO 200.

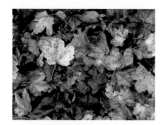

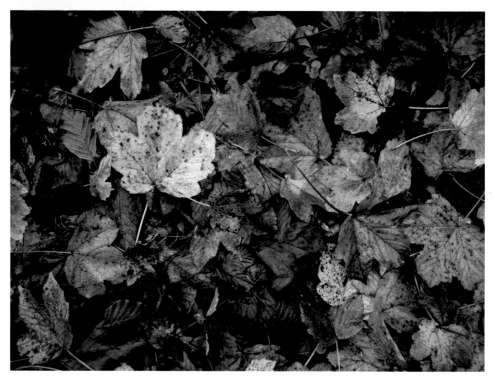

Woodland floor

Slight underexposure was commonly used to increase colour saturation with slide film. With a modern digital camera having an accurate and not an under-reading meter, like that used for this image, it is sometimes helpful to intentionally reduce the exposure by up to 1EV to increase the colour saturation and enhance the mood of subjects such as these richly coloured leaves.

Photographer: David G Präkel.

Technical summary: Canon G9 12.7mm (50mm 35mm equivalent) 1/60 at f/3.2 ISO 400 main image -1EV.

Underexposure

Underexposure occurs when there is not enough light entering the camera. There are a number of reasons why underexposure can occur, including the lens aperture being too small, the chosen shutter speed being too short or the sensitivity or film speed being set too high. Automatic light meter errors on digital cameras are often intentionally biased towards underexposure to avoid the unrecoverable problems of overexposure.

With digital images and slide films the result of underexposure will be a dark image with no true shadow detail. Shadows will look inky black and will be without detail or any subtle tonal gradation – these are described as 'blocked-up'. There is hope for an underexposed digital image however. If the underexposure is not too great a good result can be obtained by careful adjustment. However, **banding** and, in particular, noise can be a problem in re-balancing heavily underexposed images. There simply is not enough data to work with. Some techniques for dealing with digital underexposure are discussed in the next section.

With film negatives, underexposure will produce a thin image. This will only produce dark, lifeless prints with no shadow detail at all. Looking carefully at the negative it may be possible to see faint detail in the thin (shadow) parts of the negative – if there is some information present it may be possible to enhance this chemically using an **intensifier**. The best intensifiers are sadly now considered too poisonous to be sold and those that are available are rather mild in their action but for an important image this may be the only option.

Intentional underexposure can be used to create mood, making an image more mysterious by not showing detail and letting the shadows lap into the image. Again, mid-tone adjustment after intentional underexposure will produce the best result. Though neither over- nor underexposure is recommended, it is easier to correct an underexposed digital image than one that is overexposed and it is far easier to print from an overexposed negative. This is rather like the advice: 'If you are going to fall off your bicycle, at least fall on the side away from the traffic.'

Banding
Description of the visible effect of posterisation where abrupt changes in colour produce the appearance of coloured bands in what should be natural and continuously changing tones; this is usually because of exaggerated changes in contrast producing insufficient levels of tone to convey a smooth gradation.

Intensifier
Chemical used to increase film negative density by adding silver or altering film silver with selenium or chromium salts (uranium was once popular!). Used as a last resort to make an underexposed or underdeveloped negative printable.

Dealing with accidental underexposure in post-production

This section relates only to digital images. (Underexposed black-and-white negatives can really only be improved by chemical intensification, which is outside the scope of this book but detailed in the companion volume *Basics Photography: Working in Black & White*.) Looking at the image histogram will immediately tell you if the image is underexposed. For an average scene, the histogram should be roughly centred – an underexposed image will show a distinct left bias toward dark tones and no highlight information whatsoever. Images captured in RAW format will respond far better to adjustment than JPEG captures. These are recovery techniques only. For a fuller explanation of the problems of relying on Photoshop to treat underexposure see pages 120–121.

The simplest technique to improve an underexposed image is to use the Levels command and pull the white point down to meet the histogram data – the image contrast can then be adjusted with the gamma slider. You can use the white point and black point eyedroppers to designate new white and black points though this can clip image data if a true white and a true black are not chosen.

Improving an underexposed image using the Levels command

This is the simplest technique for improving an underexposed image.

A far more controlled technique uses the blending modes between image layers and relies on using image-editing software that features Layers. It may seem a strange thing to do but the technique starts with making a copy of the original dark image as a layer over itself. The layer interaction is then changed from Normal – which has no effect – to Screen, which begins to lighten the image. Screen is an odd choice of word but it is meant to give the idea of one image being projected on to a screen and subsequent images projected on top – the overall effect on the screen would be brighter. This is what you now do in the Layer palette: duplicate the Screen layer time after time until you achieve the desired rebalancing. Use layer Opacity to fine-tune. The image can then be flattened, as it will have grown to a cumbersome size with all the extra layers. This technique offers the finest control for the adjustment of underexposed images. If needed, a Curve adjustment layer could finally be used to adjust contrast.

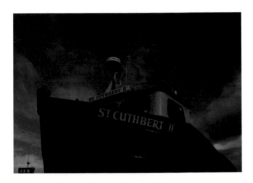

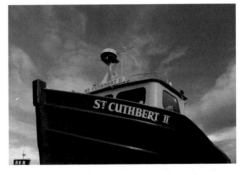

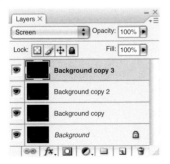

Improving an underexposed image using Layers
This is a more controlled technique for improving underexposed images.

Clipping

The origins of the word 'clipping' are in signal processing and communications technology. If a sensor has a limit on the range of signals it can handle, once that limit is reached, higher or lower level signals are simply recorded at that limit. The best thing to do with clipping is to avoid it altogether during exposure.

In photography clipped highlights are described as 'blown-out'. There is no data beyond paper white and when printed that area of the image will carry no ink (in an inkjet print) or no dot (unless adjusted for magazine or book publication). The result is an ugly hole in the image. This can be filled with **tone** by adjusting the output in the Curve or Levels dialogue, limiting highlight output to a very light grey (usually level 249). This effectively puts a solid four to five per cent grey tone into the blown-out highlights. This technique should not be relied upon – get it right in the camera.

The opposite of blown-out highlights is 'blocked-up' shadows that have no detail. Darkest parts of a print look as if someone has spilled black ink on the print. There is really no way out of the situation as you cannot put detail into the image that is not there – some workers use digital noise, as lightening the area produces an even less satisfactory washed-out appearance. Again it is best to avoid the situation by exposing correctly.

Camera **RAW files** have latitude in exposure and can be adjusted to bring back highlight detail – a process known as 'recovery'. For the shadows it is surprising just how much information can be extracted from the depths of a digital image with careful adjustment of the tone curves. Unwanted noise may appear very quickly however. For more information on RAW files see pages 104–105 and 126–129.

Traditional photography with film and darkroom produced prints tends to be a little more graceful than digital capture and printing when it comes to extreme over- and underexposure. The characteristic curve tells us that film will naturally retain some shadow and highlight detail in the gentle slopes of the 'toe' and 'shoulder' areas of the graph. The digital response is usually more linear.

Tone

In photography: full range of greys from solid black through dark greys, to mid-grey and light greys to pure white. In printing: tones are produced by using patterns of black (or coloured) ink dots on white paper and may be referred to as a percentage.

RAW file

Camera RAW or RAW format files come straight from the digital camera sensor without first being processed by the camera. RAW files feature 12- or 14-bit resolution permitting non-destructive editing, exposure and white balance latitude.

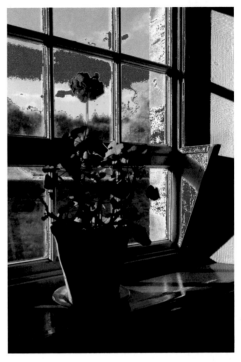

Clipping

High-contrast original image (bottom left) – pixels clipped or close to clipping can be shown using false colours – blue shadow clipping (above left) and red highlight clipping (above right). The Adobe Lightroom histogram (below) shows the bunching of pixels at the white and black points and the illuminated clipping indicators.

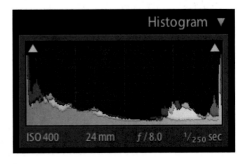

Key

The word 'key', as used in the phrases high-key and low-key, refers to the tonal balance of the image. The idea originated in the era of classic black-and-white portraiture. A sitter for a portrait will be initially lit with a key light. This is used to set the overall mood and main lighting effect. Its quality, strength and direction will determine the overall look and mood of the final print. The shadows cast by the main or key light are then moderated or manipulated using other lights to create the overall look of the portrait. Three 'key' looks were commonly created in classic photographic portraiture – high-key images, which were predominantly light, low-key images, which were predominantly dark, and mid-key images, which are rarely mentioned nowadays! Biasing the distribution of tone in an image towards dark or light is in the control of the studio photographer and this has a major effect on the mood and emotion picked up by the viewer.

High-key images are seen as being clean and innocent; low-key images will be seen more as gloomy and weighty, possibly even threatening. Stereotypically women, babies, young boys and girls get the high-key treatment while men are more often photographed in low-key settings. The modern photographer can of course play with these conventions though it is hard to see many parents opting for a low-key baby portrait.

High-key images are most certainly not light, overexposed images. Conversely, low-key images are not simply dark and underexposed. Both types of image have a full tonal range that will include all tones from solid black through to near paper white. Using a reflected light meter such as the one in your camera to set the exposure for either high-key or low-key images will result in under- or overexposure respectively. The light meter will always suggest an exposure that will produce an average mid-grey tone (see pages 94–97 for more information). It is important therefore to use a light meter that measures the light falling on the subject – if one is available – rather than a meter that measures the reflected light from either the predominantly light or dark tones in the high- and low-key setups.

High- and low-key images are often incorrectly thought of as being low in contrast. On the contrary, a properly exposed high- or low-key image will have a strong contrast. In fact, it is something of a tradition among photographers specialising in high- and low-key portraiture to introduce a dark shadow, however small, to prove to the viewer this is a true full-toned image and not just a poorly executed overexposure. The small dark shadow in the high-key image or the bright highlight in a low-key image is important to secure the full effect of the technique.

High-key and low-key

High-key and low-key fashion images; both contain a full tonal range but are biased towards the light tones and dark tones respectively.

Photographer: Caroline Leeming.

Original exposure details: (High) Canon EOS-1Ds Mark II EF 28-70/2.8L USM (at 48mm) 1/60 at f/20 ISO 100 Flash. (Low) Canon EOS 20D EF 28-80/2.8L at 35mm (56mm 35mm equivalent) 1/125 at f/16 ISO 100 Flash.

Speed and sensitivity

Three things control exposure: sensitivity, intensity and duration – film speed or ISO sensitivity on a digital camera, lens aperture and shutter speed respectively. Looking at things historically for the moment, film speed is a measure of how quickly a film will turn black when exposed to a known and controlled amount of light. Though standards existed they were different in Britain, Europe and America – standardisation of the test for sensitivity and the scale came about only in the early 1990s and was done by the International Organization for Standardization (ISO). The 1960s arithmetic American Standards Association (ASA) system and the older German Institute for Standardization (DIN) logarithmic numbers were combined with an emphasis on producing films at whole stop intervals:

25/15 50/18 100/21 200/24 400/27 800/30 1600/33 3200/36

Film speed is expressed in ISO numbers, which combine both systems as in: ISO 100/21. Each film in this sequence is double the speed of the film to its left and half the speed of the film to its right. For example: ISO 400/27 film is twice as fast as ISO 200/24 speed film but only half as fast as 800/30. In other words the law of reciprocity holds true for sensitivity just as it does for intensity or duration. (The logarithmic DIN derived number is rarely if ever seen on digital cameras, which simply use ISO 100, ISO 200 etc.)

The smaller the number then the slower the film is to react to light or the less sensitive the digital sensor. Conversely, the bigger the number the faster the film reacts and the more sensitive the sensor. Sensitivity can therefore be related to camera shutter speed and lens aperture in terms of exposure 'stops'. As a one-stop change means a halving or doubling of exposure, so ISO 200 can be said to be one stop faster than ISO 100 – which is like getting an f/2.8 lens instead of an f/4 or being able to use 1/30 second shutter speed instead of 1/15 second, whether you are using film or a digital camera.

Whichever type of film you choose, you have an initial choice over film speed. Fast films need less light for a satisfactory image than slow films. So, why not always use the fastest film you can buy? As ever there is always a price to pay for speed. Faster films are less good at recording tone or colour and they show more grain. This means you are limited in the size of enlargement you can make before you begin to see the 'grain' structure of film that comprises your image tones.

Similar compromises come with digital sensitivity settings – the ISO settings on a digital camera match the film sensitivities of the same number. If film suffers from ever more visible grain with increasing film speed then digital cameras suffer from increasing noise at higher sensitivity settings – this can be either monochromatic noise or colour (chroma) noise.

Venerable Beech

Exaggerated film grain from fast films (detail top) can be appropriate with the right subject.

Photographer: David G Präkel.

Technical summary: Leica R8 16mm f/2.8 Fisheye-Elmarit-R 1/750 at f/13 Kodak TMax 3200 at EI 3200 stand developed in Rodinal diluted 1:100 for one hour, scanned from darkroom print on Grade 5 paper.

Once you choose to use and load a specific film – short of removing the film from the camera and substituting another or chopping the film in half to develop each half separately – you are bound to expose the whole film at the same film speed. That may not be the speed recommended by the manufacturer but more of that later in the next section on Exposure Index and on pages 140–141.

It was only with sheet film in larger format cameras that film speed would be considered as part of the overall exposure judgement. The majority of photographers using miniature 35mm film or medium-format roll film cameras adopted this 'fixed film speed' way of working as a necessity. Because film speed is not considered at the point each exposure is made this has tended to prevent sensitivity from taking its proper place as one of the three equally important exposure variables.

Early digital cameras, with their poor noise performance at anything other than low sensitivities, tended to encourage this way of working. Automatic ISO setting on digital cameras was made available from the outset as part of automatic exposure modes. Using this setting could, however, lead to a higher proportion of noisy pictures than desirable. The 'intelligent' camera electronics would favour faster shutter speeds (to avoid camera shake) and smaller apertures (to maximise the appearance of sharpness) at the expense of noise from higher chosen ISO settings. As subsequent generations of digital camera offered far greater acceptable noise performance across a wider range of sensitivities, ISO sensitivity can finally come into its own as part of the exposure setting. It should now be considered and adjusted on an image-by-image basis if required.

The exceptional noise performance of some recent professional digital cameras in the sensitivity range ISO 100–1600, and sometimes even above, has lead to an entirely new way of working. On pages 102–103 you will read how camera automation can control aperture in aperture priority mode, shutter speed in shutter priority mode or both shutter speed and aperture in program mode. In manual mode you choose the ISO sensitivity, aperture and shutter speed yourself. However, with ISO sensitivity variable over a four-stop range without any significant noise penalty, sensitivity can finally be set as the automatically adjusted variable where it is essential to retain both a particular shutter speed and aperture in changing light conditions.

Bowl of grapes

With ever-improving camera noise performance it will become increasingly difficult to use digital noise from a high ISO setting to create the kind of colourful granularity shown here.

Photographer: David G Präkel.

Technical summary: Nikon D100 28–105mm f/3.5–4.5D IF Zoom Nikkor at 55mm (82mm 35mm equivalent) 1/50 at f/11 ISO 6400 (Hi-2).

Exposure Index (EI)

Look carefully at a film manufacturer's range of black-and-white products and you may notice something odd about the apparent regular spacing of the film speeds. Modern black-and-white film will be available at ISO 100 and 400, 1600 and possibly 3200. But look carefully at the boxes. While the 100 and 400 films speeds are true ISO speeds, the faster speed films are prefixed by EI1600 or P3200 and do not refer back to the international standard for film speed. This is because they cannot be rated at the advertised speed under that standard – they can be exposed at that speed but will need a different developer from the standard or will need effectively to be overdeveloped to achieve printable negatives.

The P rating stands for Push – some say it stands for Personal as in your own Exposure Index. EI stands for just that – Exposure Index. The use of a P or an EI number on a box of film allows manufacturers to market film for particular uses and at regular one-stop increments in speed. You must read carefully how to achieve that film speed on the instructions with the film and use the recommended developer.

Your own way of working as a photographer may mean you would be better off not exposing even an ISO rated film at the advertised rating. The developer you use, the way you agitate the film and the temperature you use for development, your light meter and any personal 'fine tuning' of the exposure reading will all add up to a deviation from the norm.

Not too many years ago you could rapidly establish your own film EI by exposing a flatly lit grey card at a variety of shutter speeds. You were looking for the exposure given to produce the first useful density over the density of the blank film. You matched this frame with a given density wedge on the Kodak Projection Print Scale. Sadly, the Projection Print Scale is no longer produced and this technique now requires an expensive **densitometer** to measure the negative densities. It is possible to scan the film and use image-editing software to make the readings but this introduces scanning as an unwanted variable. A personal EI is a means of fine-tuning print quality and you might wish to gain access to a densitometer (transmission type) through a college or professional film lab. Digital photographers can establish their camera's true ISO in a similar fashion.

Densitometer
An instrument used to measure the optical density of a negative (transmission) or a print (reflectance).
Used for calibrating the development and printing process.

Calibrating digital exposure index

You may wish to establish the true ISO sensitivity of your digital camera's light meter. This is essential if you wish to use a digital version of the Zone System to visualise tonality and control placement of tones in the final print. Pointing a digital camera at a reference grey card and taking a picture usually results in a histogram that shows the exposure peak to the left of middle grey – this is partly the effect of the 'fiddle factor' mentioned on page 94 and partly due to the conservative nature of digital camera design in trying to avoid highlight clipping. Digital cameras may show something like one half to one third of a stop underexposure.

To determine the effective ISO of your camera, try the following: Find the manufacturer's default ISO setting. Set the default value on the camera. Switch the camera to manual focus and exposure, set the lens to infinity and set to record in RAW format. With an evenly illuminated reference grey card, fill the frame and, with the camera on a tripod so you can repeat the shots, get in close to the card. (See pages 96–97 for the best results.) Choose an aperture that gives you a range of shutter speeds above half a second. Centre the meter and take a Zone V mid-grey shot. Now shoot a series of exposures using a third of a stop by adjusting the shutter speed only from one stop below to one stop above the indicated exposure. You will then have a set of seven images representing ISO 50 64 80 100 125 160 200. Convert all to 16-bit grey images (use no adjustment in RAW processing at all) and the frame that has the closest value to level 128 (Zone V value) is the correct ISO to use for your camera. Using this sensitivity instead of the default helps you place a mid-tone accurately.

Film speed and ISO

Looking at the film box ends you would assume you were dealing with 400 and 3200 speed versions of the same film. Closer inspection of the data panels shows that while the Delta 400 film is a true ISO 400/27 rated film, the 3200 speed film has a recommended Exposure Index (EI) of 3200. Its true ISO rating is probably nearer 1600.

Filters

Because filters cut down the amount of light reaching the film, some compensation has to be made by increasing the exposure. (The exception is the UV filter or so-called digital protector.) The degree of light reduction varies depending on the filter. The filter manufacturer will supply a filter factor, which is usually marked on the filter mount in the case of a screw-in glass filter.

You will certainly see the effect of a fitted filter through your SLR viewfinder and while it is convenient to use through-the-lens (TTL) metering, it is not always safe to rely on the meter reading. Some meters are only accurate when measuring white light (or a rough mixture of all wavelengths) and not filtered light (this, of course, does not apply to neutral density filters). It is safest to take a reading without the filter, fit the filter and increase the exposure as suggested in the table below or according to the filter manufacturer's recommendations.

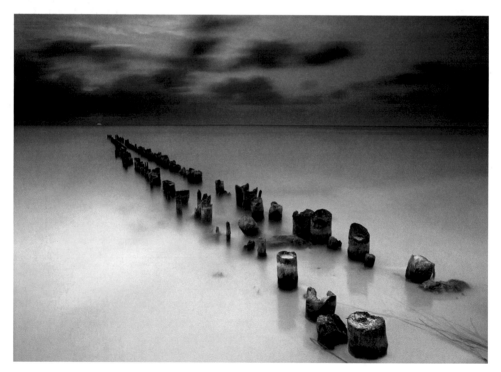

Swept Away: Isla Mujeres, Mexico

In very low-light situations you may not consider a filter useful but a graduated filter has been used here to tame the brightness in the sky even with this lengthy exposure. Cloud and water movement is clearly visible but adds to the mystery of the image.

Photographer: Patrick Smith.

Original exposure details: Canon 5D Canon EF 17-40mm f/4.0 L USM Lee graduated filters.

Filter factor	f-stop
1	none
1.2	1/4
1.25	1/3
1.4	1/2
1.6	2/3
1.7	3/4
2	1
4	2
8	3
16	4

A special technique is required for metering with polarisers and graduated ND filters to make the most out of the effect they offer. If you look at a polarising filter it looks a lot like an ND filter – the filter factor supplied by the manufacturer applies to the effect it has on non-polarised light. Polarisers do act like ND filters and you can get a good exposure using a before-fitting reading and applying just the manufacturer's filter factor, rotating the filter to adjust reflections. The effect of the rotated polariser is done to taste and there can be no hard and fast rules about adjusting for the effect. I would advise bracketing for film users and a little experimentation for the digitally equipped photographer. You can always use the camera's small area metering function to meter off a known mid-tone in the polarised image which will give you the correct fall of the tones in your finished image. With a linear polariser on a manual larger or medium-format camera the filter factor is all you can use.

When using a Grad ND filter, you need to meter a mid-tone that falls in the clear part of the filter for the best results. Alternatively, you can meter the unfiltered scene; if you are using an automatic or semi-automatic setting, transfer the reading to the camera set on manual and then add the filter. Metering with the filter in place will give an unwanted overall lightening effect.

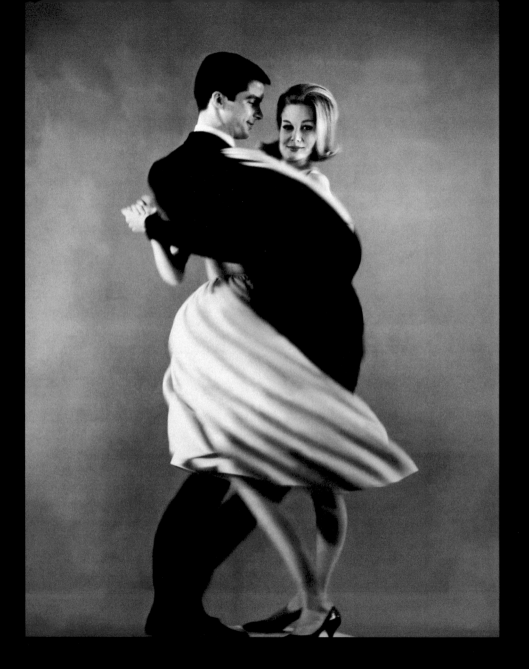

Because of the low sensitivity of the films then in use, early photographers did not need a mechanism to regulate light entering their camera lens. Photographic emulsions were slow to react to light and thus required a long exposure. To make an exposure the photographer would simple uncap the lens, wait a sufficient time for the exposure to be made and re-cap the lens. This naturally limited the subject matter that could satisfactorily be photographed to subjects that did not move during the exposure.

As more sensitive, faster-working films became available it became more and more necessary to accurately control the time for which the photographic plate was exposed in the camera. This led to the development of a shutter system whereby light could be let into the lens in a controlled manner and for a precise time.

The modern shutter is a mechanical system of blades or blinds that controls the time during which light reaches the film. Today we have inherited two successful mechanical systems in our cameras: one uses a travelling slit in the focal plane of the lens, the other comprises a set of leaves that hinge to block the light – the focal plane shutter and the leaf shutter. These different mechanisms can produce quite different photographic results. Film and digital sensors need the correct exposure (the right amount of light) to make a good picture. As lighting conditions and subjects vary so we must control the amount of light energy reaching the film or sensor. The shutter controls the length of time (duration) the light falls on the film or sensor and it is one of the prime means of controlling exposure.

Though it is commonly accepted that the photograph generally shows the 'truth' or at least a true record of a given situation, it is not commonly realised that the use of lenses and especially the use of a shutter to expose a photographic image creates a unique untruth. Taking just the effect of the shutter for the moment, every picture taken with a focal-plane shutter distorts the image of any object that moves during the exposure. At its simplest, shutter speed gives you control over the appearance of motion. Slow speeds produce blurred images with moving objects. Fast shutter speeds can freeze movement. Although the photographic image sometimes coincides with our own experience of the world it is only that: a coincidence.

Danseurs
To create this dramatic but 'impossible' image, photographer Robert Doisneau chose a travelling-slit shutter on large-format film. His posing dancers were still but were rotated together on a turntable in front of the camera. As they turned the moving shutter slit sequentially exposed part of them from top to bottom of the frame to produce the appearance of entwining, moving dancers.

Photographer: Robert Doisneau.

Technical summary: None supplied.

Motion and time

Manipulating shutter speed gives the photographer control over the appearance – or non-appearance – of motion. Slow shutter speeds will give blurred images of moving objects. Fast shutter speeds can freeze the movement of moving objects. If the subject is not moving, a longer exposure can be given. The blurred trails of moving objects in photographic images have a fascinating and impossible quality of being 'see-through'. None of these effects are how we perceive the world but we have come to understand these effects seen in photographic images and can use them to emphasise concepts such as 'hurry' or 'rest'.

Whether chosen from a menu or a mechanical dial, shutter speeds are double or half the duration of their neighbours in the sequence. The faster shutter speeds are in fractions of a second but usually only the bottom number of the fraction appears as in the sequence:

1	2	4	8	15	30	60	125	250	500	1000	2000
1sec	1/2	1/4	1/8	1/15	1/30	1/60	1/125	1/250	1/500	1/1000	1/2000

Early popular cameras had two settings: I and B. The B stands for Bulb (though some people refer to it as Brief), which means the shutter is open for as long as the shutter button is held down. The I stood for 'instantaneous', which with most cameras meant between 1/50 and 1/100th of a second.

Some lenses – especially those used with large-format cameras – have a T setting for Time, which means the shutter is latched open – the first click of the shutter button opens the shutter, the second closes it. Unlike the Bulb setting, you do not have to hold on to the shutter button. This setting is used to keep the shutter open while you focus and compose your image on the ground-glass screen view camera.

Sometimes a speed is marked X or has a lightning bolt symbol; sometimes one speed is marked in a contrasting colour. This is the fastest flash synchronisation speed for that camera, which may be as slow as 1/60 sec or as fast as 1/250 depending on the camera.

It is possible to create two types of motion blur with a camera – one comes from the subject moving during the exposure and this is called subject blur. The other is when the whole camera moves. When this is an unwanted effect it is known as 'camera shake'. You need to know how and when it comes about to be able to achieve clean unblurred pictures when you want them. (Though there is no reason why you cannot move your camera during an exposure – you just need to know what the results may be and why you are doing it!)

You may shake the camera and blur the image if you try to hand hold too slow a shutter speed. Learn to stand correctly with your camera to prevent camera shake – feet shoulder width apart, knees flexed, elbows in to the hips for support, left hand below the lens with the palm supporting the camera. Do not stab down on the shutter release but ease it off by flexing your finger. Learn to lean for support and look for places to steady yourself. Use a tripod or camera support when you need to – but a bag of rice or lentils makes a great lens support!

A good rule of thumb is to check that you can hand hold the shutter speed equivalent to the reciprocal of (1 over) the focal length of the lens (see lens notes). Below this speed you need to consider a tripod or other support. For example:

50mm lens – 1/50 – nearest faster shutter speed = 1/60
200mm lens – 1/200 – nearest faster shutter speed = 1/250

If you use a zoom lens remember to use a faster shutter speed when zooming towards the telephoto end of its range to avoid camera shake. Program metering mode takes this into account when the camera's on-board light metering computer computes the appropriate combination of shutter speed and aperture to achieve a good exposure.

Shutter speeds for typical subjects with a standard lens (50mm on a 35mm film camera or digital equivalent)

Car on the race track	1/1000	Pan to follow the car.
Sport/football/athletics	1/500	Slower will blur the action.
Portraits	1/60	Remember to increase shutter speed if you change to a longer focal length 'portrait' lens.
Landscape	1/60	Slower shutter speeds are entirely possible if it is not windy. Use a tripod.
General leisure/parties/people	1/250	
Animals	1/500	Depends on the animal and what it is doing!
Night shots	1 sec and above	Always use some form of camera support. A 10–20 second exposure is needed to get traffic 'streaks'.
Fireworks or lightning	B (Bulb)	Hold or lock the shutter open and use lens cap or a piece of black card on/off to capture bursts or flashes.

Neutral Density (ND) filters to extend time

There may be a time, when photographing outdoors for instance, that you run out of exposure options. Certain manual camera and lens combinations, for example, offer only 1000th of a second as the fastest shutter speed and a minimum aperture of f/16. If you are loaded with ISO 400 film, you can rapidly get into situations, especially in sunny conditions at higher altitudes, where you need to cut down the light entering the camera.

Alternatively, you may be using a lower speed film but the day is so bright that you cannot get a long enough shutter speed to blur some features. This is a surprisingly common problem for landscape photographers who like the look of motion-blurred water in their images and need a shutter speed of half a second or more to achieve that.

The solution in both instances is to cut down the intensity of light by not using the lens aperture but by using a neutral density filter in front of the lens. A neutral density filter (commonly referred to as an ND filter) cuts out light equally at all wavelengths (all colours) and thus appears grey. Some digital cameras, especially higher-quality compact cameras, offer an ND filter mode that reduces light intensity by three stops to an eighth of the actual level, which allows for slower shutter speeds (or smaller aperture values).

Physical filters are available in a variety of densities as screw-in glass or rectangular resin system filters. Filter manufacturers may refer to ND-2, ND-4, ND-8 filters – this is pretty easy to understand as they let through half, quarter and one eighth the light (that is a one-stop, two-stop and three-stop reduction respectively). Confusion arises when other manufacturers use the density 0.3, 0.6, 0.9 descriptions for these same filters. A 0.3 filter is the same as an ND-2, passing half the light and blocking half – it offers a one-stop reduction, in other words.

ND filters can be stacked on the lens but the filter factors need to be multiplied, not added, together. (If you stack filters be careful not to vignette the corners of the image – this is harder to see with the darker image created by ND filters.) The three densities referred to above are the commonly available filters. If you are looking for very special effects you may need to seek out filters that are often available only by special order and are used for specialist imaging connected with industry or solar astronomy.

ND filter		Percentage light transmitted	Increase exposure by
0.3	ND-2	50%	1 stop
0.6	ND-4	25%	2 stops
0.9	ND-8	13%	3 stops

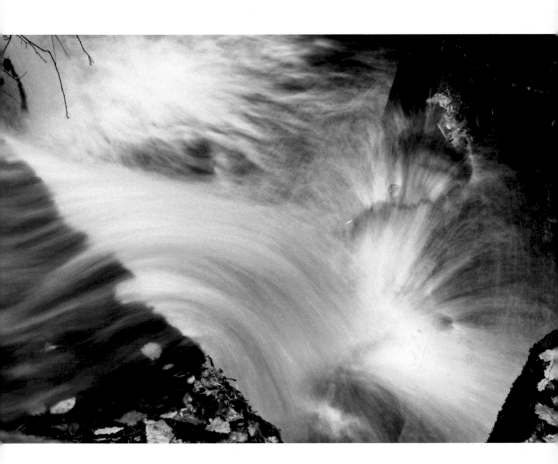

Waterfall on Hareshaw Burn

The digital camera used for this image has a fast minimum sensitivity of ISO 200, so to achieve a long enough exposure to show the power of the flowing water – half a second – a 0.3 ND filter was added.

Photographer: David G Präkel.

Technical summary: Nikon D100 60mm f/2.8D AF Micro 1/2 sec at f/32 ISO 200.

Types of shutter

Focal-plane shutter

The focal-plane shutter is any shutter mechanism that lies in the focal plane of the lens. Today, we take this also to mean a travelling slit shutter where (for the highest shutter speeds at least) the film is progressively exposed by a narrow slit of a constant size that travels rapidly either horizontally or vertically across the film.

Longer shutter speeds are achieved with a slit wider than the film itself. For long exposures, the first curtain of the shutter mechanism moves away to expose the film. After the chosen exposure time has elapsed, the second part of the shutter – the second curtain – moves across the film to prevent light reaching it and effectively ending the exposure.

Early shutters were made of cloth, or rubberised cloth. Where these shutters are employed in modern SLR cameras, either film or digital, they more often use electromechanically controlled metal foils. These shutters can nowadays achieve fantastically short exposures, many SLRs having 1/4000 or 1/8000 as a fastest shutter speed.

Focal-plane shutter

Above: Vertical running focal-plane shutter made with cloth blinds.

Right: The first curtain uncovers the film; the second follows behind and covers up the film.

Above right: Focal-plane shutter – image area during exposure.

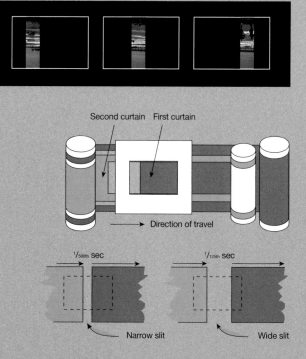

Second curtain First curtain

→ Direction of travel

1/500th sec 1/125th sec

Narrow slit Wide slit

Leaf shutter

The alternative shutter mechanism is the more complex leaf shutter often found in medium-format and large-format camera lenses. Leaf shutters are so called because they are made up of 'leaves' that are hinged at one end to swing over to prevent light passing through the lens. Being small and lightweight they can open quickly and all swing closed again at the end of the exposure.

Leaf shutters are fitted either in the camera body or more commonly between the elements of the lens where they can be made small. This means you have to buy a new shutter with every lens (making these lenses more expensive than their SLR counterparts, which need only the lens elements, focusing and an aperture mechanism on the lens itself).

Leaf shutter

Left: Do not confuse the leaf shutter with the blades of the iris that form the aperture mechanism.

Above: In-camera image area during exposure.

Below: As soon as the leaves start to open, under the action of a controlled spring mechanism, the image begins to form dimly inside the camera.

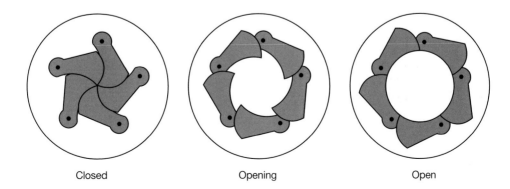

Closed Opening Open

Focal-plane shutters – effects on imagery

It has been explained that at high shutter speeds above about 1/60th second the film in a camera with a focal-plane shutter is being exposed over a short period of time by a moving slit. The travelling slit exposes one side of the frame before the other side. Objects that travel during the exposure in the direction of the slit will be elongated in the finished image. Objects that travel against the direction of travel of the slit will be shortened. Only the objects that were stationary will be imaged 'correctly'. Most modern focal-plane shutters are designed to travel top to bottom of the frame (with the noticeable exception of Leica), which means the image expansion compression with moving objects occurs only in the vertical.

Focal-plane shutters pose a problem for flash sync as they expose the negative a bit at a time through their travelling slit. The only synchronisation that can work is opening the first shutter curtain, firing the flash then closing the second curtain. The time taken to do that limits the fastest flash-sync speed with focal-plane shutters. Choose too high a speed and part of the frame will be blanked out by one or other of the shutter blinds not having cleared the film aperture.

Digital cameras employ a variety of shutters. Inexpensive compact cameras with a 'live' rear screen have no mechanical shutter at all. The shutter speed is the time taken to electronically sample the pixels exposed to light by the lens. Digital SLR cameras use a mechanical focal-plane shutter to simplify the sensor. This does not need switching devices if the shutter speed exposure time is handled by a mechanical device – the sensor is always on behind the closed shutter blinds. Some cameras have hybrid shutters with mechanical shutters and sophisticated electronics to handle high flash synchronisation from pulsed flashes. The high syncing shutter speeds, however, do not work with conventional studio flash systems and only with compatible flashguns from a given manufacturer's system.

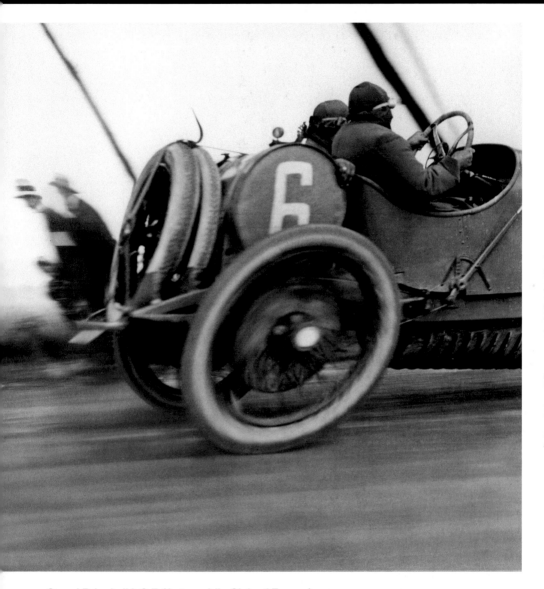

Grand Prix de l'A.C.F. (Automobile Club of France)

The slow-moving horizontal focal-plane shutter and the fact that Lartigue followed the car's motion with his camera creates the sharp image of the racing car and the elliptical wheel that appears to lean right while the blurred background leans left. This dramatic distortion of the image – the camera's own reality – has gained iconic status in depicting the motorcar and speed. Taken on 26 June 1912.

Photographer: Jacques Henri Lartigue.

Technical summary: Ica Reflex 3 1/2 by 4 3/4 inch glass plate negative Zeiss Tessar 150mm f/4.5, exposure not recorded.

Chef Raymond Blanc

With failing light this difficult shot requires a camera with a leaf shutter to afford maximum flexibility of flash and shutter-synchronisation speeds and to give fine control of the balance between ambient light and the flash-lit subject.

Photographer: Murdo Mcleod.

Technical summary: Bronica GS1 Bronica PG 100mm f/3.5 1/8 at f/5.6 Fuji 220 Provia ISO 100. Flash with umbrella from left with reflector out of shot right. Scanned from a 6x7cm transparency, no post-processing.

Leaf shutters – effects on imagery
The major advantage of the leaf shutter for the photographer is that flash can be synchronised at all shutter speeds. This permits fine control over the balance between ambient light in the image and what the light of the flash exposes. The details of this technique (commonly called syncro sun) are covered on pages 158–159. But it is for this ability to balance out flash over a range of shutter speeds that professionals prefer the leaf shutters in medium-format camera lenses to the focal plane shutters in 35mm and most digital SLR cameras. Some medium-format camera systems feature both a focal-plane shutter in the camera body and leaf shutters in the lenses to give alternative cost and performance options.

Focal-plane shutters are limited to maximum flash sync speeds of between 1/60 and 1/250 sec because the first curtain has fully to clear the film before the second curtain closes, which limits the fastest speeds at which synchronisation can happen. With a leaf shutter the whole image begins being exposed the moment that the leaf shutter starts to open as is shown on page 63.

In actuality it is practically impossible with normal subject matter to tell what kind of shutter was employed – leaf or focal-plane. What is important is to understand the opportunities and limitations of the equipment you choose to use and the effect it could have on your photographic choices and your approach.

'What makes photography a strange invention – with unforeseeable consequences – is that primary raw materials are light and time.'
John Berger

Creative use of shutter speed

Blur

On pages 58–59 the idea of motion blur was introduced and some guidance given on how to avoid it. You may however want to exaggerate blur and use the effect creatively – here's how. A blurred image is read by the viewer as depicting speed. Interestingly, it actually shows the passing of time, any movement being integrated throughout the duration of the exposure. It is most informative to look at precisely which parts of the image are sharp (and therefore not moving during a long exposure) and which parts of the image are blurred (and therefore moving). A crisp image of a car against a blurred and clearly moving background is as effective an image as one of a blurred car moving across a sharp background in depicting speed and motion. However, only one approach is of use in a car manufacturer's advertisement!

It is important to distinguish between two types of blur. Camera blur is when the camera itself moves during the exposure. With a normal scene this produces an overall blur in the final image. The photographer can control this by intentionally moving the camera in one direction or moving the camera in a circular motion – one would create trail blurs through the image, the other would produce a circular blur with objects towards the edges of the circle more blurred than those in the centre.

A further effect can be achieved when part of the subject is itself moving. Moving the camera in the same direction as the moving subject will tend to keep the subject sharp but will blur the background. Moving the camera against the direction of movement will double the effective blur on the subject and still blur the background. Moving the camera during exposure is the basis of panning. This is most commonly seen in images of sporting races – the images in any car or bike magazine will feature the technique somewhere. This gives the impression of speed and dynamic movement. If the subject is obscured by a stationary foreground (the crowd line), panning can produce a 'see through' effect by blurring the foreground as well as the background. These techniques require practice to master but the best advice is to use a follow-through – keep the camera moving in pace with the moving subject after you've pressed the shutter.

If the camera is stationary and the subject moves during the exposure then this is known as subject blur. The moving object will appear to be 'see through' as during the exposure the subject will move to reveal various parts of the background. Long exposures and a solidly clamped camera can produce blurs from moving vehicles or people, the effect of wind on leaves and turn water into a milky smudge.

A neutral density filter may be needed to achieve a long shutter speed on a bright day (see pages 60–61 for ideas). For extremely long shutter speeds using the B (Bulb) setting, refer to the section on open-shutter photography on pages 166–167.

One-legged pedestrian (1950)

A long shutter speed coupled with perfect timing blurs the pedestrian's moving body to invisibility, leaving only the one motionless foot firmly planted on the ground during his stride.

Photographer: Otto Steinert.

Technical summary: None supplied.

Boys Cumberland and Westmorland wrestling

A fast shutter speed freezes peak action, leaving the wrestlers forever mid-fall while the necessarily wide aperture puts the crowd into soft focus.

Photographer: David G Präkel.

Technical summary: Nikon D100 28-85mm f/3.5-4.5D AF Zoom-Nikkor at 55mm (82.5mm 35mm equivalent) 1/2000 at f/4.8 ISO 200.

Freeze

Shutter speed gives you mastery of time; instead of blurring a moving subject you could consider freezing the motion. When experimenting, it comes as a surprise how short a shutter speed is required to freeze some common motions; a galloping horse that nearly fills your frame and is moving across your sight line may still show some blur towards the ends of its feet or in the mane at shutter speeds of around 1/2000 of a second. Most high-end digital SLRs offer a maximum speed of 1/8000 of a second, which is matched by similar quality film cameras. Medium-format cameras (both digital and film) are often limited to a fastest shutter speed of around 1/2000 of a second while the lenses used on large-format cameras rarely feature a speed faster than 1/500 of a second as many share the same Copal or Prontor shutter mechanisms. Even manufacturer's shutters enabling you to use shutter-less lenses rarely feature any speed faster than 1/500 of a second and older mechanically controlled leaf shutters often top out at 1/60 of a second. Depending on your photo project, the maximum available shutter speed may limit your choice of camera and format.

A bright day and a fast lens (one with a large maximum aperture (small f-number)) are needed to get the fastest shutter speeds. If you cannot add light, or open the lens up further to admit more light, only then consider increasing sensitivity or changing to a faster film. You will otherwise get into the quality issues of **noise** and **grain**. Usually a compromise will have to be struck between minimising noise and getting the picture at all. You may want to turn to flash to add light but remember the maximum sync speed of your camera with flash will limit the motion-freezing effect in the final image. Images where the motion is frozen solely by flash are taken using flash only in darkened studios where a flash duration in the order of tens of thousandths of a second freezes movement. The chosen shutter speed is for flash synchronisation purposes only and has no effect as there is no ambient light.

In the thick of the action it is possible not to notice that the shutter speed in automatic or program mode has dropped below that which will freeze motion of your chosen subject. This is where you need to choose shutter priority mode on your camera and set a minimum speed that is fast enough to freeze any motion – the camera will automatically choose a matching aperture. Again you may have to compromise and increase sensitivity or change to a faster film stock. For full details of using shutter priority turn to pages 102–103.

Noise

Out-of-place pixels that break up smooth tones in a digital image. Can be colour (chroma) noise or luminance (luma) noise or a combination of both.

Grain

Appearance in the final image of the individual specks of silver from the film negative that make up the tones of the picture.

This chapter looks at what is actually a side effect of using a mechanism to change the brightness of the image cast inside the camera by the lens. This adjustable hole or aperture produces the appearance of increased sharpness around the point at which the camera is focused. This is known as depth of field. Because you need to adjust aperture to make a good exposure, you also have to deal with the depth of field it introduces. This additionally means you have to take control of where the camera is focused.

Understanding aperture means having a grasp of the simple number system of f-stops used to determine how much light is being let through the lens. These numbers have been standardised to give a scale based on the halving and doubling relationship with neighbours (this was discussed on page 28).

Where you focus has a major effect on what else appears to be in focus in your image. Choice of aperture can throw a background completely out of focus. This is one of the fundamental techniques used by photographers to control where their viewers look, and to determine precisely how much of the subject they see in the final print.

An understanding of depth of field can lead to an appropriate choice of aperture and point of focus to get an object to fall entirely within the depth of field. It will then appear to be sharply focused from front to back. These skills are necessary to enable you to operate in either the studio or outdoors.

The chapter's aim is to stress that these apparent technical considerations lie at the heart of creative photography and that they can be deeply involved in exposure considerations. It includes some reflection on how advances in digital imaging technology may change how photographers operate in the future.

The sword divides
Using maximum aperture guarantees that what you see through the lens of an SLR camera (in terms of point of focus and depth of field) is exactly what you will see in the final image. Focusing inside the sword handle guarantees it is all in sharp focus, yet the re-enactor behind is recognisable but not in competing focus. With anything other than maximum aperture, depth of field preview would have to be used to judge depth of field – the compositional moment may have passed in the time taken for that.

Photographer: David G Präkel.

Technical summary: Nikon D200 18-200mm f/3.5-5.6G VR AF-S DX IF-ED Zoom-Nikkor at 75mm (112mm 35mm equivalent) 1/100 at f/5 ISO 100.

f-numbers and stops

The simplest way to produce an image inside a camera is with a pinhole. Light is reflected from every part of the illuminated subject. For each point on the subject the pinhole restricts the light falling on the film or sensor to a small circle. These small image circles overlap to form the total image.

A lens has the property of focusing light. Light from a single point on the illuminated subject falling on the lens is focused at a single point behind the lens. It can be thought of as gathering light over its whole surface. This makes a brighter, sharper image than that from a pinhole. However, it is a focused image and exists in sharp detail only at the focal plane inside the camera. The lens focuses the light to produce a sharper image than the pinhole but it is important to remember that – like the pinhole image – the total image is the accumulation of all such points. It is important to think of the focused lens image as consisting of tiny overlapping points to understand ideas like 'bokeh' and how depth of field occurs (which will be explained on pages 80–81).

Early users of lenses would notice how precise the point of focus was. In front of and behind this point, the image created would be blurred and indistinct. Blur is one of the unique properties of all lens-based media; what we are talking about here is lens blur rather than the motion blur mentioned in an earlier chapter on shutter speed. There is no concept of focus with a pinhole. Move the photosensitive material closer to the pinhole in the camera and you get a brighter but smaller image – move it away and conversely you get a dimmer, bigger image. The bigger the pinhole, the bigger the overlapping image circles and the brighter the image but the less detail the image will show.

A lens on the other hand needs to be focused. Photographers refer to 'critical focus', meaning that a lens is focused as sharply as it possibly can be. Some lenses may resolve more detail or show a different degree of distortion (these are called lens aberrations). With a lens critically focused there is a two-dimensional image plane inside the camera. This is the focal plane and it has a depth of focus. Out in the world is what should technically be described as a 'field plane' but it is more commonly and loosely referred to as the plane of focus. It can help to think of a thin two-dimensional plane cutting through the three-dimensional world that corresponds with the sharp two-dimensional image inside the camera.

We have already said that good exposure requires some control over the brightness of the image – this comes from reducing the diameter of the cone of light from the back of the lens with a circular 'stop' or iris mechanism. It is this device or mechanism that produces the side effect of depth of field (increased apparent sharpness in front of and behind the point of focus) as a side effect of reducing the brightness of the lens.

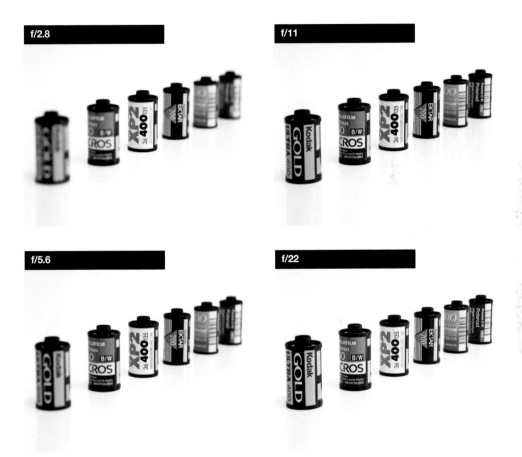

f/2.8

f/11

f/5.6

f/22

Depth of field – what it looks like

Focus was on the black, white and red film canister, third back in the row. Focus was not changed between images. As the aperture is reduced, the depth of field grows fully to encompass the whole row – front and back canisters are clearly readable in the final image. The aperture was adjusted two stops between each image, reducing the light by one quarter each time. Shutter speed was adjusted to take into account the reduced intensity in accordance with the law of reciprocity (page 28) from 1/60 in the first image at wide aperture to one second in the final image. See if you can work out what the other two exposures were.

The idea of the stop was introduced on pages 26–27. The mechanism controlling the amount of light passing through a modern lens is the **iris**. The iris is made of metal leaves that can be closed down to restrict the light passing through the lens. The variable-sized hole this creates is called the aperture. The so-called f-stop numbers (or just f-numbers) are used to indicate how much light is passing through the lens.

At maximum aperture (what photographers call 'fully open') all the glass of the lens is used. As some lenses let through more light than others (depending on size and complexity), each lens is referred to by its maximum aperture: an 'f/2 lens' or an 'f/1.4 lens' for example. A lens with a wide maximum aperture will commonly be described as a 'fast' lens; one with a small maximum aperture (usually around f/4 or f/5.6) as a 'slow' lens. This is a subjective measure of the light gathering 'power' of the lens. At minimum aperture, little light gets through and the lens is said to be 'stopped right down'.

Aperture is defined as: the diameter of the lens opening as a fraction of the focal length. Focal length is given the letter f in classical optics and so the f-number is a ratio of the aperture to the focal length. It gives a measure of brightness of the image. A 50mm-focal-length lens with a lens opening of 50mm would have a 50:50, 1:1 relationship and would be described as an f/1 lens (they do exist but cost a lot of money, as they involve a lot of expensive glass in their manufacture). A 50mm-lens with an opening of 25mm would be have a 25:50 or 1:2 ratio and be a focal length over 2 or an f/2 lens. A 50mm-focal-length f/4 lens would have lens opening of 12.5mm to give the 1:4 ratio.

It is the circular hole – the aperture – that lets through the light. Because we are dealing with the area of circles (or the equivalent area in the case of metal-bladed irises), the mathematics involves the constant Pi. The formula for the area of a circle is Pi multiplied by the square of the radius ($\pi \times r^2$). The halving and doubling numbers starting from one are rounded to give the familiar f-stop number sequence where each setting passes exactly half as much light as its neighbour above and twice as much light as its neighbour below.

Iris

A mechanism between the lens elements comprising flat overlapping plates that can be adjusted to change the size of the hole – or aperture – at its centre. This is used to control the intensity of the light passing through the camera lens and is homologous to the iris in the human eye.

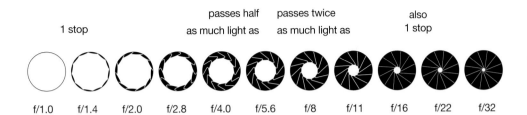

	1 stop			passes half as much light as	passes twice as much light as			also 1 stop		
f/1.0	f/1.4	f/2.0	f/2.8	f/4.0	f/5.6	f/8	f/11	f/16	f/22	f/32

Apertures

The interval is called a 'stop'; there is one stop from f/2.8 to f/4 and one stop from f/16 to f/22. What confuses many people, because it is counter-intuitive, is that a small number means lots of light, a bigger number means less light. It is easier to remember if you think of the f-number as being the size of the lens opening as a fraction of the focal length – the wider the window the more light comes in. Zoom lenses may have variable maximum apertures such as f/3.5–5.6. This simply means that the lens loses light gathering power as it is zoomed towards its maximum focal length.

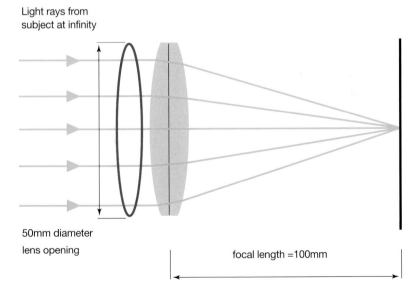

Light rays from subject at infinity

50mm diameter lens opening

focal length =100mm

f-number

Aperture is the diameter of the lens opening as a fraction of the focal length – in this example focal length/lens opening 100/50 = f/2 aperture.

Depth of field

What is depth of field?
Reducing the aperture ('stopping down' a lens) also has the effect of increasing the depth of field. That means more of the image is in acceptable focus in front of and behind the point where the lens is critically focused. It is the sharp part of the image that concerns depth of field, not the degree of background blur.

If the subject is kept the same size in the final image and the same aperture used, a wide angle and telephoto will have the same depth of field. The telephoto lens may appear to have more background blur but magnifying the background detail in the wide-angle shot to the same size will show it to be identical. The telephoto lens simply shows less of the background and brings it closer to the viewer. (A lot of confusion comes about because we view all prints from wide-angle and telephoto lenses at the same viewing distance.)

The small circles that overlap to form the overall image, which we encountered when talking about pinholes, are called 'circles of confusion' or blur circles. It is the size of these circles that give us the notion of 'acceptably sharp'. It relates to what you see as a point as opposed to a small circle in the final print – the resolving power of your eyes is roughly 1/3000 the viewing distance. Miniature-format film with large magnification to the final print will need smaller circles of confusion to achieve the same apparent sharpness as a less magnified large-format image. Miniature-format film with large magnification needs smaller circles of confusion to achieve as sharp a looking print as large format – the kind of size we are talking about is roughly 0.025mm for 35mm negatives and 0.1mm for 5in x 4in large-format negatives.

The circles of confusion will actually take on the shape of the aperture – this can be seen in highlights in a stopped-down lens, which will show the shape of the aperture (five, seven or many sided). Waterhouse stops (see pages 26–27) give perfectly circular circles of confusion and superbly 'creamy' out of focus quality. Japanese camera enthusiasts first described the quality of the out of focus areas of an image as 'bokeh'. Some lens iris designs give a very jarring geometric quality to out of focus portions of the image that can be very distracting with certain subjects.

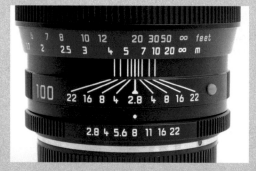

Depth of field scale
Many prime lenses (ones with a single fixed focal length) commonly have a scale to show what will be in acceptable focus for any aperture setting. This 100mm lens is focused at six metres – at an aperture of f/22 everything from about four-and-a-quarter metres to ten metres will be in acceptable focus, at f/8 this will drop to five to seven metres according to the scale.

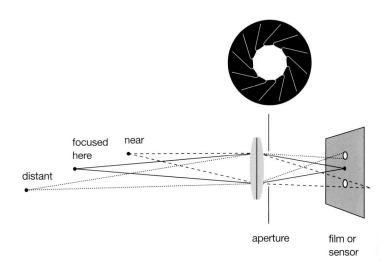

focused here near

distant

aperture film or sensor

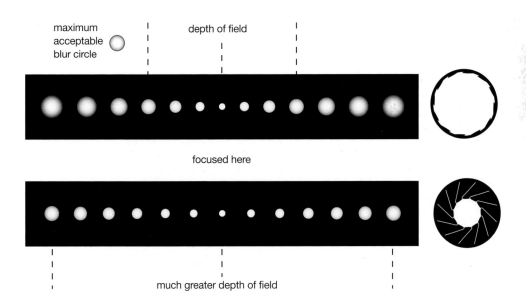

maximum acceptable blur circle

depth of field

focused here

much greater depth of field

How points on subjects in front of and behind the point of critical focus reproduce as blur circles inside the camera

A degree of blur is acceptable, as the blur circle cannot be distinguished from a point in the final image – this gives depth of field. Smaller 'circles of confusion' appear as aperture is reduced (up to the point at which diffraction effects begin (close to minimum aperture)).

Depth of field and format

Given the same field of view (which means changing the focal length to suit the format), smaller formats have greater depth of field than large formats. Camera phones and small compact digital cameras have so much depth of field that they frustrate seasoned photographers because they cannot use their traditional techniques of differential focus and blurred out of focus areas in an image. Photographers who came to the early generations of professional and prosumer digital cameras with their 24mm APS-sized imaging sensors from 35mm film cameras were surprised by the increased difficulty in separating subject from background using aperture and depth of field effects.

As the film format or digital sensor gets larger the depth of field gets shallower. Comparisons must be made with the same field of view – the images must have the same content. Depth of field depends on the aperture dimension and when you scale the focal length up for the larger format you have to scale the f-number as well. So the depth of field you would get stopping a 35mm film camera down to f/8 would only be matched on the large-format camera by stopping down to f/32 or thereabouts.

Shallow depth of field is one of the joys you will discover with medium-format and large-format photography. Roll film medium-format cameras, even without tilts or swings, have a very distinct plane of focus that can be precisely placed and then increased using lens aperture. Large-format cameras of 5in x 4in and above not only have very limited depth of field but the plane of focus can be manipulated to fall in quite unexpected places by using the front (lens board) and back (film plane) swings and tilts available on these cameras. This type of photographic freedom has been the preserve of the large-format camera and expensive film materials. However, there are niche products that provide technical camera movements for digital SLR camera users, such as the Cambo X2-PRO System.

The downside of smaller imaging formats being used is that students are provided with fewer opportunities to sample the delights of limited depth of field photography and when they need to introduce shallow depth of field their only resort is to use Photoshop layers and blurring techniques. On the plus side digital technology is beginning to open up imaging techniques that could only be dreamed of with traditional film. These are not image manipulations or filtering and special effects but radical techniques such as focus stacking. In this technique a number of in-focus slices of an image can be digitally combined into one image with massive depth of field. Computational cameras point the way to the future of photography and include lens arrays over the digital sensor that will enable images to be refocused after the picture is taken. This technology may also permit correction of all types of lens aberration.

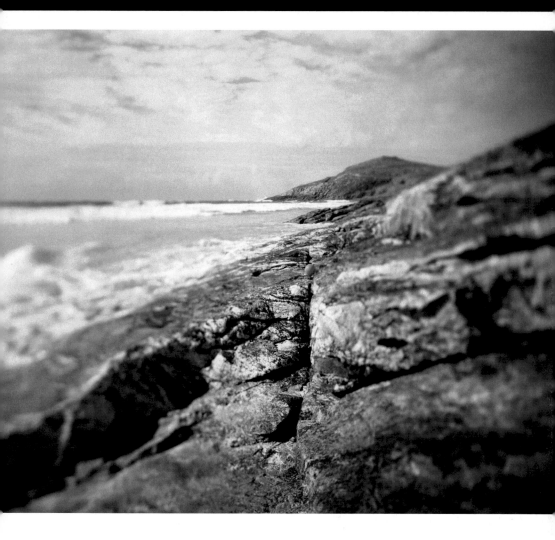

From the Western Isles project

Large formats have inherently limited depth of field which can be manipulated using the lens and film shifts on a view camera to produce dramatic effects like this. The plane of focus runs unexpectedly front to back in the image drawing the viewer's attention down the rock crevice to the fishing net buoy.

Photographer: Mike England.

Technical summary: Ebony SW45 (5x4 field camera) Nikkor-SW 90mm f/4.5 1/125 at f/5.6 Fujicolour PRO160 ISO 160. Reflected light and grey card meter readings. Negative scanned on Hasselblad Flextight, levels adjusted in Photoshop but no other post-production work.

Hyperfocal focusing

Landscape photographers use hyperfocal focusing to achieve the incredible depth of field in their photographs. (Many professional landscape photographers use view cameras where the plane of focus and sharpness can be controlled to a far greater degree than with just aperture – these photographers still use their knowledge of hyperfocal focusing.)

Depth of field

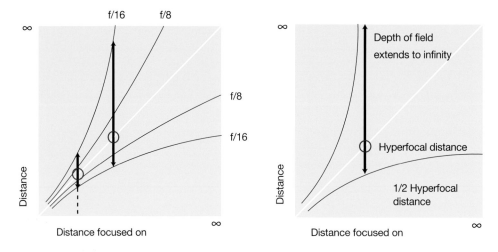

Looking at the diagram of depth of field there is a focal distance where the rear depth of field will reach infinity – it will be different for different apertures. Go no further! If you continue to focus the camera closer and closer towards infinity at this aperture you will begin to waste the available depth of field. Objects close to you will appear to be more and more out of focus while objects at infinity will seem to stay as sharp as they ever were. Technically speaking, the light rays from an object at infinity arrive in parallel. In practical terms, infinity can be thought of as the horizon in landscape photography and, depending on the lens, anything beyond 15 metres for a wide angle and 75 metres for a short telephoto. For a very long focus lens infinity must be taken as being over 1000 metres.

Hyperfocal focusing maximises the available depth of field for any given aperture. Focusing your camera at the hyperfocal distance ensures everything from infinity back to half the hyperfocal distance appears to be sharp, as shown in the second diagram. The whole basis of hyperfocal focusing rests on what is defined as acceptably sharp. It is computed back from the circles of confusion and needs to be worked out for any given focal length of lens, format and aperture. Hyperfocal focusing puts the biggest acceptable circle of confusion at infinity.

Hyperfocal distance calculators are available at many websites. It is convenient to calculate the hyperfocal distances at various apertures for your lenses and print them on a piece of paper to have with you for reference in the field. Even if you never refer to the calculations or use the exact hyperfocal distance, knowledge of the effect will improve your control over depth of field. In a view that includes the distant hills or horizon, never focus on infinity despite the autofocus system in your camera wanting to do just that. Focus closer – the one third/two third rule is better than nothing for general views. If in doubt check the effect in the viewfinder.

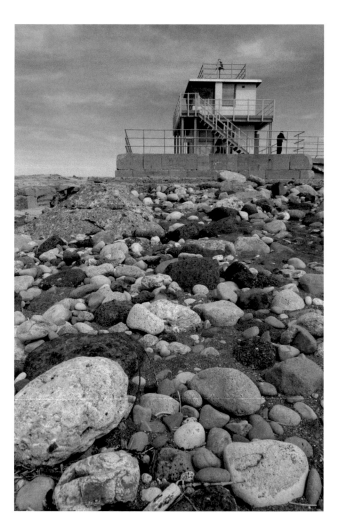

Post-industrial shoreline, Workington, Cumbria

Even with a super-wide-angle lens and a small aperture, hyperfocal focusing will give the greatest possible depth of field for the given aperture – for this image the lens was focused about 1.5m distant (just in front of the red brick halfway up the left edge of the image) and the effect previewed using the stop down depth of field preview feature.

Photographer: David G Präkel.

Technical summary: Nikon D200 18-200mm f/3.5-5.6G VR AF-S DX IF-ED Zoom-Nikkor at 18mm (27mm 35mm equivalent) hyperfocal focusing 1/350 at f/10 ISO 200. Barrel distortion corrected in Lens Fix software.

Creative use

Focus can be thought of as the way of attracting and holding the viewer's attention in your image. Without you there to tell them what to look at, their eyes will go to the point of greatest contrast and detail first.

However, your subject does not have to be sharply in focus – you may wish to play games with the viewer and keep them guessing. There are many reasons why you might wish to delay the viewer from seeing the real subject of your picture. Focusing away from the main subject can achieve just that. This is very easy to achieve with a manual focus lens, though not so easy with an autofocus lens and camera. You will have to pick a focus point manually and steer the camera's focusing system towards the object on which you want it to focus. Point an autofocus camera at two people to frame heads and shoulders and unless the camera is set to wide-area focusing the chances are it will focus straight through the gap between the heads on to the wall behind and unintentionally put the subjects out of focus. Unless you know how to choose an off-centre focusing point – or focus with the subject in the centre and then recompose the image – you are not in control of this aspect of your composition.

So if focus can be one of the ways to attract and retain the viewer's attention it can also be a way to introduce mystery and a sense of 'something not revealed' in an image.

Think of focus as dropping like an infinitely thin plane through your subject. With all miniature formats and fixed lens cameras, this is always parallel to the back of the camera. (Tilt/shift lenses and technical cameras are special case exceptions.) You can move this plane forwards and backwards through the subject at will as you focus the lens. A smaller aperture will then increase depth of field – objects in front of and behind the point of focus will become more distinct. An even smaller aperture will make the depth of field extend yet further in front of and behind the plane of focus.

In portraiture, you need to get the subject (foreground) to stand out from the background. You can use colour to do this in the studio but with an environmental portrait you may have similar colour or tone in the subject's face and the background. This is when focus and shallow depth of field come to your rescue. By critically focusing on the most important part of the subject – usually the eyes – and choosing a wide aperture, the background can be attractively defocused so it no longer competes with the subject for the viewer's attention.

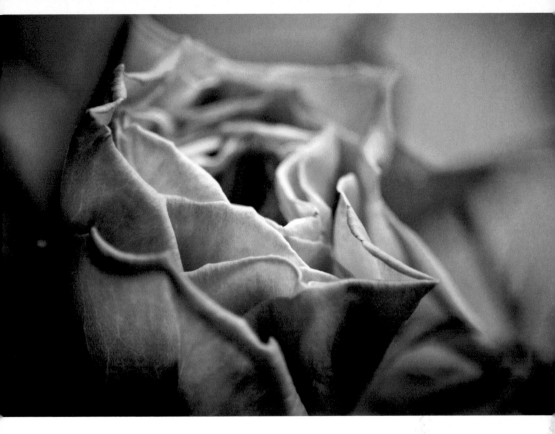

Rose

The use of a supplementary close-up lens on a telephoto zoom lens gives an incredibly shallow available depth of field at maximum aperture. Focusing slightly above the subject allows the furthest point of the shallow depth of field to just kiss the subject to create a glowing soft-focus effect. The richness of the colour was further emphasised by slight underexposure in the camera.

Photographer: David G Präkel.

Technical summary: Nikon D80 70-300mm f/4-5.6D AF ED Zoom-Nikkor at 135mm (202mm 35mm equivalent) fitted with Nikon 6T supplementary close-up lens (+2.9 dioptre) 1/100 at f/4.5 -1/3EV ISO 160.

Teds

Focusing beyond the obvious foreground subject creates a sense of closeness and possibly unwanted intimacy in this wide-angle shot. The in-focus background and out-of-focus foreground subjects create a greater depth and interest.

Photographer: Chris Steele-Perkins (Magnum).

Technical summary: None supplied.

Get used to the idea of having a plane of focus that cuts through your subject parallel to the camera back. Remember that if you tip the camera, the plane will now cut through the subject on an angle. Imagine a less well-focused area that exists in front of and behind your plane of focus and which can be extended or shrunk around it. There you have the basis of how to picture depth of field at work.

Depth of field does not grow evenly in front of and behind the plane of focus as you stop the lens down. Common advice is to imagine it extending one third in front and two thirds behind – this is useful advice but certainly not true in many photographic situations. In close-up photography the relationship is more likely to be half in front and half behind.

Autofocus seems like your best friend when you first get a camera but in controlling depth of field it can be less than helpful. You wish to photograph a horse that is standing at an angle to you. Without adjustment, the autofocus camera will probably focus on the animal's muzzle and throw the majority of its body out of focus. To make the best of your available depth of field you may have to move the point of focus back from where you feel it ought to be, for safety's sake – on the eyes for instance. So to maximise depth of field you may need to focus on the shoulder of the animal, which has no texture or contrast for the autofocus system to lock on to. In such circumstances you may need to switch to manual focus and make a best guess.

There are also occasions when you have to focus on fresh air. In the studio you can dangle a piece of squared paper where you need the camera to focus (camera autofocus systems love squared paper), lock the focus and move the paper out of shot when you take the picture. Outdoors you may have to focus on a point in mid-air, halfway between a tree and a hill, for example. Sadly, you can't put a piece of paper up there. The technique of first focusing in front of and then behind the subject on clear, easy-to-focus subjects and then setting the focus point in between is used to achieve final focus.

Your autofocus camera will give an indication of an in-focus subject even in manual focusing modes if you are not confident focusing without aids; look in the operating manual that came with the camera for 'focus confirmation indicator'.

Setting your point of focus is putting down your anchor for the depth of field that will result from your chosen aperture. As such, it is a vital part of the considerations around exposure. Some camera metering systems will steer the point at which the light meter reading for you, but beware – where you focus can have a big impact on the final choice of automatic exposure even in the same composition with the camera locked down on a tripod.

Pioneer photographers soon understood that in order to get a good exposure every time, especially with their expensive and difficult-to-use materials and processes, some way of measuring exposure rather than a guess or estimation was needed. This chapter opens with a review of the development of the modern high-sensitivity hand-held light meter.

You can choose to measure the light falling on the subject or you can measure the light reflected from the scene. There are light meters that do one or the other and meters that do both but how you interpret the information they give is key to a good exposure. The drawbacks of the commonly used reflected light meter and ways to interpret the readings from it are assessed in this chapter.

Nearly every modern camera features a reflective light meter of some sort. Sophisticated metering patterns and intelligent use of look-up tables containing thousands of prior successful exposures lie behind the apparent simplicity of the modern camera auto exposure. This section looks at the different metering modes offered by camera manufacturers, their strengths and their disadvantages.

Because cameras rely on reflected light meters, however sophisticated their 'intelligent' assessment of the scene, some method of compensating for the reflective nature of what is being photographed is usually needed. A section of this chapter looks at how single strong colours can confuse camera light meters and how exposure compensation can be applied to overcome misreading with tricky subjects that are either all-dark or all-light.

Some light meters work in continuous light while others are designed for measuring the brief burst of light from photographic flash. The differences are explored and explained. This chapter also looks in some depth at a light meter that doesn't give exposure readings at all: the colour temperature meter. Another specialist meter is the spot meter. How this differs from the spot meter function on some cameras is explained. A true spot meter can give very misleading results if not used correctly and without knowledge about what it is meant to be measuring. A final thought is given to reasons why you need to get the exposure right in the camera and not rely on image-editing software to make corrections.

Power Station
Understanding your camera's light meter gives you full expressive control over your images as with this difficult to meter backlit subject.

Photographer: Adrian Wilson.

Technical summary: Canon 5D Canon 17-40mm f/4 L USM at 17mm at f/16 ISO 100. ND grad filter 0.9 (Cokin ZPRO). Spot metered off the sky. RAW capture image cropped, horizon straightened, levels adjusted and local contrast adjusted in the plumes of steam using Photoshop contrast curve.

Types of exposure meter

Development of the light meter

Early photographers based exposure on experience and subjective judgement but it soon became clear that systematisation of exposure and a method of measuring light to set exposure accurately was needed.

The earliest light meters were based on the darkening of some photosensitive material when exposed to light – these are known as actinometers. The time taken to reach a specific tone was noted and used as the basis for exposure. None are produced today but the collector of photographic paraphernalia will be familiar with the disc-shaped Watkins Bee light meter. Another older type of meter was the extinction meter where the light was used to illuminate a series of numbers or letters set behind a progressively darker filter in a simple viewer; the brighter the light, the more numbers could be seen. The last readable number gave an indication of a suitable exposure when looked up in a table. Extinction meters are not exactly reliable as the eye can accommodate quickly and sensitivity differs between individuals.

A photometer uses the eye's ability to match brightness levels but requires an illuminant of known value. The last camera to use an exposure meter based on this principle was the Polaroid Swinger with an elegantly simple meter where the aperture was adjusted until the word 'Yes' appeared in the viewfinder!

The first modern light meters with photoelectric cells were introduced in the early 1930s. These used the photovoltaic effect of selenium metal. Exposed to light, selenium generates a voltage in proportion. This can be used to move a sensitive galvanometer mechanism swinging a needle to a position over a calibrated scale. No battery is required but these early meters are not particularly sensitive. Cadmium Sulphide (CdS) has a photo-resistive effect – it changes its resistance in proportion to light exposure. CdS meters need a battery to operate but are often more sensitive than selenium meters.

Modern exposure meters are photoelectric devices based on silicon photodiodes. A photodiode can be used in a circuit that converts light into either an electrical current or voltage, which can show an exposure value using either a needle galvanometer or an LED or LCD readout. Film cameras once used a moving needle centred in a narrow gap; more sophisticated cameras use 'traffic light' red and green LEDs to indicate under-, over- and correct exposure.

The terms light meter and exposure meter seem to get used interchangeably. To be precise there are some light meters that are not exposure meters. A colour temperature meter measures the colour temperature of light in Kelvin and does not provide an exposure value or a combination of shutter speed and aperture readout at all. A colour temperature meter is therefore one type of light meter that is not an exposure meter.

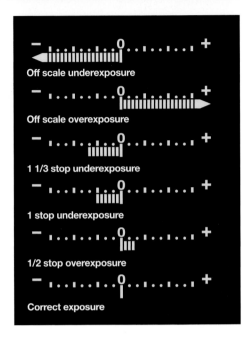

Off scale underexposure

Off scale overexposure

1 1/3 stop underexposure

1 stop underexposure

1/2 stop overexposure

Correct exposure

Common 'picket fence' display

Today's cameras give a readout of shutter speed and aperture alongside a 'picket fence' display with a central tall zero and 1/2-stop or 1 1/3-stop 'railings' marking under- and overexposure. In automatic cameras the light meter is wired directly to the electronics controlling the shutter and lens aperture and may give no readout to the user at all.

Classic Weston Euromaster exposure meter from the 1970s

The meter shown here is being used as a reflected light meter but it could be fitted with an Invercone diffuser for incident light readings. This selenium meter requires no batteries and many are still in use today. Two sensitivity scales (0–10EV and 10–16EV) are automatically selected by a baffle over the meter window; this cannot be seen but is beneath the meter in this picture.

Classic Gossen Lunasix 3 CdS battery-powered light meter from the 1980s

An updated version using modern batteries (the 3S) is still available. Range EV –4 to +17. This version can be used for reflected reading as shown here or with dome diffuser over metering cell as an incident meter. Attachments give telephoto metering (15° and 7.5° semi-spot), copy camera metering and metering from scientific instruments (microscopes etc.).

Reflected versus incident light meters

Light meters – whatever their operating principle – are designed either to read the light reflected from the subject (these are known as reflected light meters) or to read light falling on the subject (known as incident light meters).

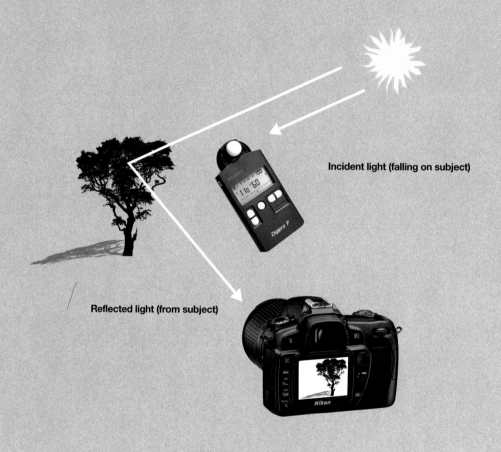

Incident light (falling on subject)

Reflected light (from subject)

Reflected light meters are used in cameras because we have to point the camera at the scene we wish to photograph. Compact cameras will have a small sensor underneath a forward-facing clear window or to the edge of the viewfinder. If you use such a camera make certain you know where the light meter cell is placed. Take care not to obstruct it or cast a shadow on it with your hand when you are holding the camera. Check with both vertical and horizontal grips.

Modern SLR and D-SLR cameras use light meters that work through the lens (TTL). This overcomes problems with external camera light meters with fixed acceptance angles being used on cameras having zoom lenses with variable angles of view. The view 'seen' by the light meter needs to match that seen by the lens at all times. TTL meters solve this problem at a stroke. Camera meters usually have switchable sensitivity patterns. Centre weighting is common; this sensitivity pattern takes more account of the subject at the centre of the frame. The so-called spot metering offered with camera light meters is better thought of as small-area reflected light metering. True spot meters measure a much narrower angle, which makes many camera 'spots' look crude. However, camera spot meters are useful for making your own average readings from highlight and shadow areas. Sensitivity patterns are detailed on pages 100–101; the use of spot meters is covered on pages 112–115.

Incident light meters are hand-held devices, usually with a diffuser over the light-sensitive cell that will average and approximate to the light falling on the subject. In some designs this can be moved aside, and the incident light meter used instead as an averaging reflected light meter by pointing it directly at the subject. The most sophisticated meters feature a diffuser that can be used in an erect position to give correct readings for the light falling on three-dimensional objects. Additionally there is a retracted position where the dome is partly let down into a dark tube – this setting is suitable for flat artwork. The retracted position can also be used to measure light directly from lamp heads in the studio to determine lighting ratios.

Incident light meter diffuser dome in raised (left) and lowered (right) positions

Why reflected light meters can let you down

There are two ways to define exposure. The definition: 'the combined effect of exposure time (shutter speed) and effective aperture' we encountered in the section on reciprocity. The other definition is a bit more difficult to explain. Scientists would accurately call it the 'time integral of **illuminance**'. Imagine a small area on the film or sensor during the exposure. From the point of view of this photosensitive material it is not just how long the shutter stays open and how wide the lens is but also what part of the scene being photographed happens to fall on that spot. This definition of exposure takes into account the luminance of the corresponding area in the scene being photographed. Luminance is the light intensity per unit area; it gives a good indication of how bright the object will be perceived.

You may now see where the problem lies with exposure meters that measure reflected light. They will give different readings depending on the reflectance of the subjects you measure. The commonly stated wisdom is that 18 per cent reflectance grey card represents the middle grey tone between black and white and is used as a standard. Technically, it isn't quite that simple. For practical purposes you can assume that every light meter made expects there to be some standard of mid-grey to which it is calibrated. For various reasons, many manufacturers use a 'fiddle factor' and there is a range of calibrations (to reflectance values between 12 and 18 per cent) found among camera and hand-held reflectance meters.

Photographic folklore tells how 18 per cent grey came about. Kodak, at the end of the nineteenth century, wanted to establish the average scene reflectance to automate their processes. After analysing thousands of amateur black-and-white pictures, Kodak scientists concluded that the average scene was represented by a surface that reflected back 18 per cent of the light that fell on it. (Because our eyes are not linear devices we see this as mid-tone grey – in case you think 50 per cent reflectance would be the half point between black and white.)

The big problem comes when you meter something other than the expected average scene – black dogs and horses that fill the frame; white dresses and iced cakes. These are real-world issues. The camera always assumes it is metering an average scene and will give exposures that make everything you put in front of it average (unless you or the camera 'intelligence' decides to do something about it). The black dog will be overexposed to make it a mid-grey dog, while the white-iced cake will be underexposed to make it mid-grey also. One solution is not to measure the light reflected off the subject but to measure the light falling on it – hence the adoption of incident light meters by professional photographers. Reflected light meters do work well but you must remember their underlying limitation.

Illuminance
A measure of the intensity of the light falling on a surface, per unit area.

Black **Grey** **White**

The limitations of reflected light meters

The accompanying images show how dramatic the limitations of a reflected light meter in an automatic camera can be. This test just uses three simple pieces of card: white, grey (not a photographic grey card but just a piece of grey coloured art card) and black. All exposures (these are uncorrected files straight from the camera) turn out looking like photographic mid-grey. This is where exposure (EV) compensation is needed to steer the exposure away from mid-grey to represent the true tone of the subject – a full explanation is given on pages 106–107.

Grey card

To get an accurate reflected light reading you can use a standardised card that reflects back 18 per cent of the light falling on it (such as that shown on the facing page). Just what the light meter wants to see. Various types of grey card are available. Some are truly made of card and need protecting against sun fade and rain, others are wipeable plastic; some are large and collapsible, some postcard sized and pocketable. All give a close approximation to the 18 per cent reflectance neutral grey that will help you establish the proper exposure when used correctly.

How to use a grey card

Readings need to be taken from the direction of the camera position and the grey card should not be in shadow or angled to reflect any brightly coloured objects or nearby light source – matt cards are best in this respect.

The grey card should not be measured square-on to the camera. Getting it right takes a bit of experience. It is recommended that you judge the angle between the main light (or the sun if you are outdoors) and the camera. Estimate one third of that angle. Starting with the card facing the camera, tilt or turn the card through one-third of that angle away from the camera. You need to do this both horizontally and vertically. Do not be over-concerned about the exactness of the angle. You just need to make some adjustment.

If you are using a hand-held meter, get in close to the card but be careful not to cast a shadow over it. When using a camera, switch to the spot meter function and measure just the grey card and none of the surrounding scene.

Using a grey card

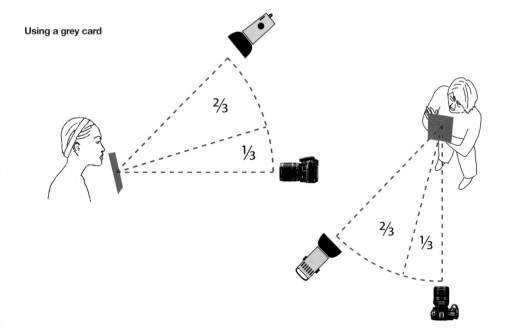

Camera light meters

So-called 'evaluative metering' is now found in many cameras. Every major manufacturer has their own brand name: (3D Matrix Metering (Nikon), Zone Metering system (Canon), Multi-segment metering (Pentax)). In each system the image is broken down into metering areas that are individually measured and compared against a database of pre-existing image measurements. Any necessary exposure adjustments can then be made accordingly. Sophisticated modern meters will give perfectly acceptable results 90 per cent of the time but can still be fooled by extreme lighting, solid blocks of one tone or colour or unusual subjects. In addition, your visualisation of the scene may not be what the designers had in mind when programming the camera.

A modern camera light meter will divide up the scene brightness into over 1000 pixel values. This data stream can be compared to that of known subjects held in the camera's internal memory. The first camera to do this was the 1983 Nikon FA using only five metering segments. (Though it could occasionally be fooled into misreading the same scene when changed from portrait to landscape format.) By 2008 this idea has reached the dizzy sophistication of Nikon's '1005-pixel 3D Color Matrix Metering II with improved scene recognition system'. This not only tries to work out what type of scene you are photographing (from the brightness distribution data) but also communicates with the camera lens to ascertain the focal length by determining what you have focused on and the colour at the focus point. The meter takes all this into account before arriving at an appropriate combination of shutter speed and aperture for the selected ISO sensitivity. In automatic mode the camera will favour faster shutter speeds with longer focal length lenses or longer focal length zoom settings to avoid camera shake.

Nikon light meter
A 1005-pixel metering sensor
from a Nikon camera.

The ultimate aim of camera manufacturers seems to be perfect automatic exposure in all situations. Scene modes help the camera automation by giving the camera a strong clue as to the type of image you want to take – for instance, Night Portrait or Winter Sports modes on some models. (There is more information about Scene modes on pages 102–103.) Compact cameras are where much of this technology and software is being trialled before its appearance in the so-called prosumer and professional D-SLR. For example, face detection (recognition) software was originally introduced to assist focusing – so the camera would focus on the people and not the background. This is now being tied into exposure systems as well so the face detection system focuses on a face and steers the spot metering function of the camera along with it to guarantee a well-exposed face. Olympus has been first to engineer this into a D-SLR. The question remains as to how successful the system can be with different skin tones.

Computer image-editing software features such as shadow and highlight adjustment are now being built right into the camera electronics – as with Nikon's Active D-Lighting system, which adjusts exposure in highlight and shadow independently.

Pentax light meter
Sixteen-segment metering matrix used in a Pentax digital SLR camera.

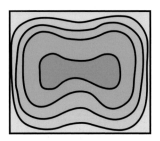

Sensitivity pattern for a medium-format metering prism
Clearly two cells are used to cover the area.

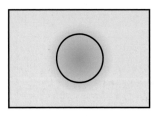

Centre-weighted metering for subjects in the centre of the frame
Seventy-five per cent of the reading comes from the central 15mm ring with only 25 per cent coming from the rest of the frame.

Camera spot meter reading in a 4mm circle centre on focus point
This represents about 1.5 per cent of the image area. Here it is used to pick a grey tone from the owl's feathers so the overall light background does not confuse the meter.

Sensitivity patterns

Camera light meters have been fine tuned over the years to overcome some of the limitations of large-area reflected light meters. Averaging out the whole image area – giving every part equal importance – to take an exposure reading would seem to be a good idea. However, there are some situations where this does not work well. Strongly backlit portraits were one of the big problems tackled by camera manufacturers. People squint when facing the sun, so it is natural to pose your subject facing away from the light for a more natural look. This however puts them in their own shadow with the light behind. Depending on how much sky is included in the frame, it is common for an average area meter to give an exposure reading that produces a satisfactory exposure for the bright sky but leaves the face too dark to recognise. Enter the centre-weighted meter.

The first camera to offer this was the confusingly named Pentax Spotmatic in the mid-1960s. Pentax wisely realised that true spot meters would not suit the amateur user and that a centre-weighted averaging meter was better. This pattern of sensitivity biases the meter reading towards the centre of the image. Nikon adopted a 65/35 split with 65 per cent of the reading coming from in and around the central 8mm circle in the viewfinder. Others used different centre weighting ratios and different sized central areas – but all gave better results than simple area averaging readings with some subjects.

Centre-weighted metering is offered on most modern cameras. Nikon now offers 75 per cent weighting with a choice of 8, 15 or 20mm circles. It is ideal when the main subject is centre-frame. You can even use centre-weighted metering when the subject is off-centre. To do this, meter with the subject centred, lock the meter reading with the exposure lock (usually marked AE-L), then recompose the picture and press the shutter. One of the most unusual centre-weighted sensitivity patterns is that in the Voigtländer Bessa cameras made by Cosina. These feature centre-weighted metering biased towards the bottom left of the image. It works well to reduce the effect of the bright sky in landscape images, whether the camera is used horizontally or vertically.

Camera light meters were further developed to offer a more extreme form of centre weighting as a third option. Although often called spot metering, there are few cameras with an acceptance angle that comes close to a dedicated spot meter. The spot meter angle in cameras is anything between 3° and 11° (where a true spot meter offers a tight 1° acceptance angle), depending on the specific camera. Camera spot meters can be made more useful by fitting a **telephoto** lens or using the telephoto end of a zoom lens to take the reading from a small area of the image.

Telephoto
A type of long-focus lens with an optical design that means it is physically shorter than its optical focal length. Telephoto lenses have narrow angles of view and give cropped and magnified images.

Camera light meters and metering modes

Early camera light meters were not coupled to the camera aperture and shutter speed controls. However, manufacturers soon realised some form of automatic camera operation could be offered once the light meter was on-board the camera. The Kodak Super Six-20 of 1938 used a selenium meter and mechanical 'trap needle' automatic aperture setting. By the 1960s electronic components were sufficiently miniaturised to allow light meters to electrically automate exposure.

Automatic setting of shutter speed – so-called Aperture priority (Av – Aperture Value – or A mode) was the first form of automation to be offered. A user could choose a suitable aperture and the camera would come up with a matching shutter speed based on its meter reading. Shutter Priority (Tv – Time Value or S mode) offers the opposite – the user chooses a shutter speed and the camera comes up with a matching aperture. The first camera to offer user selectable shutter- or aperture-priority auto exposure control was the Minolta XD-7 from 1977 (sold as the XD-11 in the US and the XD in Japan).

Today photographers choose a suitable metering mode from the Mode dial – commonly this will be marked with M (Manual control with aperture and shutter speed set independently by the user who can choose to follow or ignore the indicated exposure meter setting); A or Av (Aperture Priority); S or Tv (Shutter Priority) and P (Program). On cameras with built-in flash, there is usually also an Auto position. While Program mode sets both shutter and aperture automatically, Auto mode adds the possibility of automatic flash exposure.

On many cameras there are additional so-called Scene Modes on this same dial, with icons representing certain picture-taking scenarios; night portraits, sports, flower close-ups, for example. Each will bias the camera's automatic exposure choice towards a setting suitable for the specific picture-taking circumstance; higher shutter speed for sport, wider aperture to put the background out of focus for portraits, for example.

Pentax now offers a Sensitivity Priority (Sv) exposure mode on its digital cameras designed to automatically select the optimum combination of aperture and shutter speed for a user-selected sensitivity. Also featured on Pentax cameras is Shutter and Aperture Priority (TAv) mode designed to automatically select the most appropriate sensitivity for a user-selected shutter speed and aperture combination.

P

Program Auto for general scenes.

A (Av)

Aperture priority to control depth of field.

S (Tv)

Shutter priority to control movement.

M

Manual – entering sync speed and aperture from hand-held meter with studio flash.

Live view histogram

Camera with Live view histogram being used to photograph a white
subject on a white background.

Actual camera display

Aperture priority (Av) is being
used with Macro mode to get
good depth of field and +2/3 EV
compensation applied. The
histogram does not yet show
clipping and an extra 1/3–2/3 EV
compensation could be added,
judging the effect by changes in
the histogram and the display.

The histogram as light meter

On a digital camera the histogram can be used to see if a correct exposure has been achieved. The histogram chart should not be 'clipped' at either extreme (at the black or the white end of the chart). Clipping represents lost information in either the shadows or the highlights. Camera manufacturers make it easier to deal with the highlights (where the real problems occur) by having an additional display on the camera that can be selected to show clipped highlights which flash as a warning.

There is no such thing as a perfect histogram. Only the correct histogram (exposure) for what is in front of the camera. The shape of the histogram will reflect whether the subject is dark or light, has an even or uneven distribution of tones, but a good exposure will never be clipped or too close to the black or white limits. Ideally it should be biased to the right to give the best noise-free results. The sensor in a digital camera is a linear device with just over 4,000 levels of sensitivity; it uses 2,048 of the available 4,096 levels for the first stop where the image highlights are recorded. Each subsequent stop records half the light of the previous stop, always using half of the remaining levels. So the next darker stop gets 1,024 levels, but the next gets only 512 and so on. Ensuring best use of the sensor means producing a histogram that is as far to the right as possible without clipping. This technique is referred to as 'exposing to the right', which produces noise-free images. They will almost certainly appear unnaturally bright and need **post-processing** to produce a more natural look.

More sophisticated cameras feature separate histograms for the red, green and blue channels; photographers working with image-editing software on computers will be familiar with these histograms. Separating out the channels can be particularly useful if you are photographing a scene with one predominant colour, a bunch of red roses for example, as you can see clipping clearly in the red channel while you may not be aware of the degree of red clipping when looking at a combined display of brightness levels. Clipping the red channel in this instance means you would run out of numbers to display discrete levels of tone in the red colours – in other words, the reds would look stepped or banded.

Post-processing
Also post-production – a general term referring to any work done after the photographic image has been created.

Exposure Value (EV) compensation

If the reflected light meter needs to 'see' an average scene before giving a correct reading, it follows that it is going to get many exposures wrong. The more the scene being photographed deviates from the mid-grey equivalent the bigger the error will be, as we have already seen. The photographic situations that will cause most problems are where the frame is filled with dark or light subjects.

Camera manufacturers provide manual compensation for these very situations but it is not the most intuitive control on the camera. Many people just hope that the camera's automatic light meter will help them out. Sadly, the further from average the subject matter is, the greater the need for EV compensation and the less likely the camera's automatic meter 'intelligence' will produce a good exposure. The EV compensation button is commonly marked with a square symbol divided corner to corner with a white plus on a dark background and a black minus on white; in light conditions you need a plus compensation and in dark conditions you nee a minus compensation.

If there is any suggestion that the scene is not average it is better to use some compensation than none at all. It should become part of your photographic practice to ask of every scene, 'is this average?' and to routinely consider EV compensation. Digital cameras give you the opportunity to experiment and see the results. If you are working with a camera without an EV compensation system you need to compensate when you set the exposure manually. The same rules apply but you must use some adjustment of either shutter speed or aperture to make the compensation. Photographers using hand-held meters may change the ISO value instead.

To achieve plus one-stop compensation: open aperture by one stop, reduce shutter speed (make it longer) by one stop, use +1EV exposure compensation, and halve the ISO.

To achieve minus one-stop compensation: close aperture by one stop, increase shutter speed (make it shorter) by one stop, use -1EV exposure compensation, double the ISO, add a 0.3 ND filter (but don't change the shutter speed or aperture – manual mode only).

Some useful rules of thumb
1 For sidelit or backlit scenes, beach or snow scenes, sunsets or scenes with a bright light source, natural rendition of very light or white subject: increase exposure by one stop.
2 When the light is extremely contrasty and shadow areas with important detail are much darker than the bright areas: increase exposure by two stops.
3 For scenes where the background is much darker and bigger than subject (a light-skinned person against a dark wall, for example: reduce exposure by one stop.
4 When an extremely dark background takes up a large part of your image: reduce exposure by two stops.

Black auto

A black subject such as this will be overexposed by a camera in auto or semi-auto exposure mode.

Black EV compensated

Manual exposure compensation of -2.0EV was needed to reproduce the dark tones accurately.

White auto

A white subject will be underexposed by a camera in auto or semi-auto exposure mode.

White EV compensated

Manual exposure compensation of +1.7EV was needed to reproduce the light tones accurately.

Colour versus tone

A light meter is designed to measure white light. In other words the accuracy of its measurement relies on there being an even distribution of wavelengths (colours) in the reflected scene. There are two circumstances when this does not hold true. One is when the illuminating light source has a specific colour and is not white. Secondly, it could be a large area of a solid colour illuminated by white light. The average light meter will misread in these situations. There is no light meter made that takes into account our perception of colour – the fact that we perceive yellow as a brighter tone for instance. This effect becomes very important when creating black-and-white images that accurately reflect our perception of the brightness of the image from original colour scenes. What it means for exposure in the camera is that we cannot rely on the light meter reading to accurately reflect our perception of a scene when we are exposing for a strongly coloured illuminant or for large areas of solid colour.

This is rather like the problem with light meters expecting to 'see' the world as an average mid-tone. We have already seen that black will give a two-stop overexposure and white a two-stop underexposure. The same thing happens with solid colours. Dark greens and purples will give a one-stop overexposure (requiring compensation of minus one stop (-1EV)). This knowledge is especially important for flower and plant photographers – there is one deep purple-red Dahlia (known as 'Sam Haskins') with rich green foliage that can fool any autoexposure system! Colours close to primary red, green and blue require little or no compensation. Orange hues that dominate a scene, large areas of painted plaster walls for example, will require a plus one-stop compensation because they will cause the light meter to under-read by one stop. A solid yellow will require a one-and-a-half-stop compensation with lighter, lemon yellows getting closer to the two-stops compensation (+2EV) required for white, while earthy yellows will be closer to orange and its need for one-stop compensation (+1EV).

How do you know when compensation is needed? You have to ask yourself the same question we considered when looking at the light meter's requirement for a mid-grey tone to meter accurately. If the answer to the question 'is the scene I am about to photograph average?' is in the affirmative then no compensation is needed. If the scene could be considered in any way not to be average (darker or lighter than average, filled with light or dark colours) then you must consider exposure compensation.

Yellow wall

An image with frame-filling solid colour can cause reflected light meters to misread.
This yellow-painted wall required an extra stop in-camera from the indicated reading and a
further +0.3EV adjustment in processing to match the perceived brightness of the subject.

Photographer: David G Präkel.

Technical summary: Nikon D100 18–70mm f/3.5-4.5G AF-S DX IF-ED Zoom-Nikkor at 27mm
(40mm 35mm equivalent) 1/160 at f/11 ISO 200.

Other light meters

You will commonly see the descriptions 'ambient' or 'flash', sometimes 'flash and ambient' attributed to different light meters. We have already looked at reflected and incident light meters. There is, however, another aspect of light that affects what and how we measure. Some meters can only work with continuous light – these are described as 'ambient' or 'ambient only' light meters. Older ambient light meters used needles against a scale yet can be as accurate and useful as a modern light meter with a digital readout – if they are maintained and calibrated. Some older spot meters were ambient-only light meters and did not feature any of the flash measurement functions of the modern spot meter.

Ambient-only light meters cannot sense or measure the short burst of high energy from a flashgun. Special electronic circuits that wait for, and then measure, that burst of energy are used in light meters suitable for flash. Meters sensitive only to flash were once manufactured. The Bowens meter was a well-regarded, simple flash meter where two red LEDs were lit to get a suitable aperture reading against a scale of film speeds. You may still encounter this type of older meter in some studios. They are simple and quicker to use than modern all-purpose meters but need to be directly connected through a flash head sync cord to fire the flash to take a reading. Built-in wireless triggering is a modern convenience – though one for which you have to pay. ASA film speeds can simply be read as if they were digital ISO sensitivities.

'Flash and ambient' meters feature both types of circuit but must be switched between the two operating modes – some flash meters additionally register multiple flashes. This technique may be necessary to build up sufficient exposure with some slower films in large-format cameras using small-working apertures.

It can be important if you are choosing to buy, or are already using, an older light meter that you understand its limitations. Not only must it use currently available battery cells but it must also be capable of being calibrated. Check any second-hand light meter against measurements from a known and adjusted light meter under a variety of conditions to establish whether it can still function correctly and accurately. Sadly, the cost of repairing or adjusting an older light meter is usually higher than the value of the meter itself.

One of the most convenient light meters is a quality digital compact camera. It not only gives a histogram display and allows fine-tuning an exposure for transferring to a film camera, but it also keeps a record of that exposure. Just remember to match ISO sensitivity and the angle of view to the film and the camera/lens combination in use.

Colour temperature meters do not give an exposure reading at all but measure the colour temperature of the illuminating light – their operation and use is covered on pages 116–117.

Bowens flash meter
A simple vintage design for measuring flash only.

Gossen Digisix digital and scale ambient-only light meter
A flash/ambient version (Digiflash) is also available.

The spot meter – high and low

Spot meters are simply reflected light meters that measure off a much smaller part of the subject. True spot meters use the narrowest of acceptance angles to pick a single tone from a tiny area of the subject for measurement. They use a simple telescope viewfinder with a small circle marking the area from which the meter reads. Some hand-held meters incorporate a zoom lens viewfinder to pick off spot readings from the areas of the subject with an acceptance angle ranging from 1° to 5°. A 1° circle is the size of a common dinner plate seen 12 metres away.

A spot meter can be used to take readings from small isolated areas of the subject. So by measuring the brightest and darkest parts of the scene to be photographed, the photographer can quickly establish the subject brightness range and determine whether it is even feasible to set an exposure that can capture both highlight and shadow detail in the proposed image. All but the very oldest type of spot meters have some type of memory function to assist with this type of reading.

Typically you take a reading from the brightest area; this reading is then stored in the spot meter memory. A second reading, taken from the deepest shadow, is also made and committed to the meter's memory. The meter display will now show both readings and the dynamic range of the scene in stops as the difference between the two readings. It is best to have the meter switched to EV display where one EV is equivalent to one stop rather than at this stage to be juggling with apertures and shutter speeds. Modern spot meters will have an average function that can give a calculated reading midway between these two points. This calculated EV number is the one you then interpret as an appropriate combination of shutter speed and aperture and set manually on your camera. This reading will best capture shadow and highlight detail in the scene. In fact, modern digital hand-held meters can average up to nine spot readings. However, some care should be taken to spread these readings throughout the tonal range to avoid bias in the averaged reading towards the end of the tonal scale where the majority of the readings had been taken. For most purposes it is best to judge the brightest and darkest parts of the image and average just two readings. Complete shadow and highlight readings may skew the exposure and it is best to learn to judge the first appearance of detail in shadow areas and the last detail visible in the highlights and measure here.

Though it sounds like a long-winded and complex process in the field, with a little practice it will become second nature to take two readings and average them. It is the choice of the points in the scene from which you take your readings that can influence the final exposure and this choice still relies on your subjective judgement, which unnecessarily puts off a lot of people when they first try to use a spot meter. Experience will soon come.

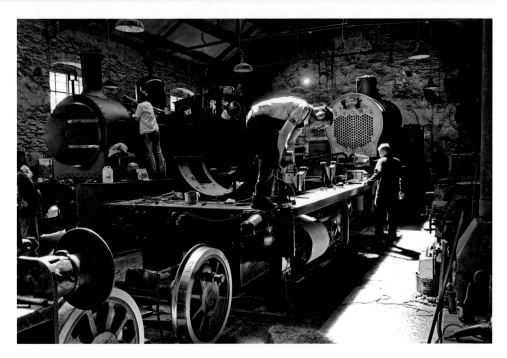

Workshop – Tanfield Railway

Dark building interior with bright sunlight gives massive dynamic range. One approach is to spot meter the highlights and shadows to obtain an average reading.

Photographer: David G. Präkel.

Technical summary: Nikon D200 12–24mm f/4 G AF-S DX (IF) Zoom-Nikkor ar 24mm (36mm 35mm equivalent) 1/15 at f/4 RAW file processed in DXO Optics Pro.

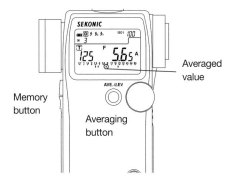

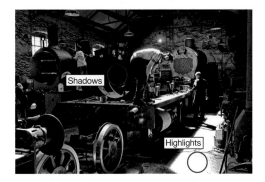

Modern spot meter

Modern spot meters can average up to nine individual measurements. This Sekonic display shows the average calculated f-stop of 5.6 from three independent readings.

Where to take the readings

The meter display will show readings from both the brightest and darkest areas and the dynamic range of the scene in stops as the difference between the two readings.

The spot meter – grey tone

An alternative method of using the spot meter is to choose an area to measure that you judge to be equivalent to mid-grey (18 per cent reflectance). You take just one spot meter reading from that tone. This technique is more prone to errors than the average high-low reading technique because it relies on your choice of a suitable mid-grey tone. It is however preferred by Zone System workers who are looking to 'place' a particular subject tone on mid-grey in their final image as part of the visualisation process.

It bears repeating that the film speed or digital sensitivity must be set correctly on a hand-held light meter before taking a reading; get into the habit of making the ISO setting on the meter the first thing you look at every time to avoid under- or over-readings. The spot meter is used to take a reading from a single small area of tone and this EV reading is then converted into a suitable combination of shutter speed and aperture for manual setting on the camera. Again the choice of tone is subjective but you will be certain that whatever subject tone you chose to meter from will reproduce as mid-grey in your final image.

It is worthwhile learning what items in the real world are at or close to mid-grey for the purposes of spot metering. Some Zone System courses take their participants out into the street with their spot meters to play 'Spot Zone V'. Zone V in the Zone System is the equivalent of mid-grey. Once a participant has chosen a particular object, tree bark, fence, or area of stone, then a reading will be taken and compared against a grey card reading in the same lighting to see how close to a real Zone V reading the chosen object was. Points can be awarded! In my experience the best items to choose for a Zone V mid-grey reading are weathered wood on a fence or building, dusty and dirty pavements or very dark Caucasian skin you would describe as 'weather-beaten'. Brown paper grocery bags can also make a surprisingly good grey card substitute. Just make certain that whatever you choose as your Zone V substitute is in the same quality of light as the overall scene and not in the shadows or in a bright refection.

Full details of the Zone System for digital and film workers are covered on pages 136–139.

'Light meters read; photographers interpret.'
Catherine Jo Morgan (American artist and painter)

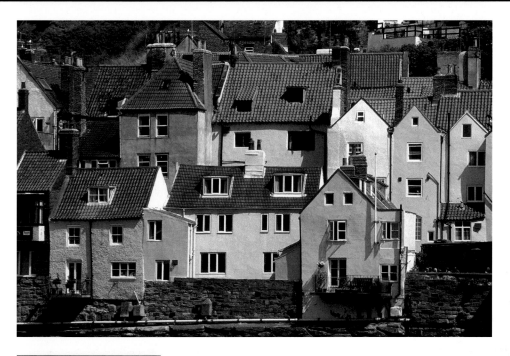

Whitby

With an unknown proportional mix of light and dark tones metering from a mid-tone grey will guarantee the correct reproduction of the full range of tones. The building upper left of centre was judged to be a suitable candidate for mid-tone spot metering.

Photographer: David G Präkel.

Technical summary: Leica R8 180mm Elmarit-R Fuji Provia 100 (processed by the author in Tetenal E6) 1/500 at f/4.

Spot meter display

View through digital spot viewer viewfinder (simulated) – one-degree angle of acceptance.

Colour temperature metering

Modern digital cameras can largely be trusted with accurate **white balance**. Using RAW capture offers the possibility of fine-tuning white balance after the images are taken without sacrificing image quality. Nikon, for a short while, included a one-touch white balance feature with a sensor at the top of the camera viewfinder prism housing – this was presumably aimed at wedding photographers who need quick and accurate white balance checking. Clearly post-production white balance and ever more accurate in-camera digital white balance seems to have made this dedicated colour temperature feature redundant almost as soon as it was introduced.

A dedicated colour temperature meter might therefore seem to be an unnecessary luxury. However, there are photographers whose practice and quality demands dictate that they use film. They need to get the image right in the camera and not during post-production. For them a top-flight colour temperature meter is an essential tool.

A colour temperature meter looks a lot like an incident light meter but it will have a flat not a domed cover over the light sensor.

Operation could not be simpler as the sensor is pointed back at the camera from a point near the subject. The measurement button is pressed and the meter immediately gives a readout of the colour temperature of the illuminating light in Kelvin. Depending on the type of camera being used the meter can be switched between digital and film operation. Different target white points are selected of 5,200K for digital cameras and 5,500K for film cameras (with the option of 3,400K/3,200K for Type A and Type B tungsten films respectively).

For illuminating light of any colour temperature the meter can be set to display the necessary filtration to achieve the correct white balance. The main light balancing and colour correction filters are shown by their numbers in the Wratten filter system while any additional colour compensation RGB or CMY is shown for example as CC10M or CC2. This indicates the strength and colour of the additional colour compensating filter to be used to achieve a perfect white balance. This direct readout is so much easier than having to use a nomograph chart to select an appropriate filter. The meter can even show the appropriate filtration using filter numbers from the Kodak Wratten, Lee system or Fuji's LBA/LBB light balancing filter system.

White balance
Adjusting for the colour temperature of the illuminating light, so white and neutral colours appear truly neutral and do not show a colour cast.

Sekonic PRODIGI COLOR C-500 temperature meter

This model is typical with a flat translucent window over the colour sensors, set in a swivelling head
with a clear LCD readout, control layout and jog wheel, matching modern light meter design.

Colour temperature readout

Readout from the C-500 meter showing colour
temperature in Kelvin with a colour correction factor.

Colour temperature readout with filter

Readout from the C-500 meter showing appropriate
Kodak Wratten filter to achieve a neutral white
balance in the measured light.

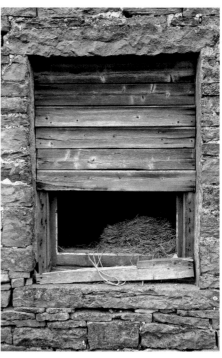

Taking readings

Meter off the palm of your hand – my palm is about one stop lighter than a grey card reference. Look for mid-tone grey (Zone V) substitutes – weathered wood gives a close-to mid-tone reading.

Making an accurate reading

When using your camera meter with the camera on a tripod, the reading will be affected by stray light entering the viewfinder. Use the viewfinder blinds (shown here on a Leica R8) or the small plastic cover supplied with the camera. Failing that, cover the viewfinder with your hand.

Alternative methods of establishing exposure

Remember the rule that reflected light meters always read to give middle grey in the final print. There are various good methods for getting an accurate and reliable meter reading. If an 18 per cent reflectance grey card gives the meter what it wants to see, use one. If you don't have one, find a suitable substitute. Remember to lock the meter reading from your grey card substitute when you recompose to take the picture. If you leave the camera set to Program Automatic it will automatically get it wrong – you must use manual exposure or the exposure lock with a grey card or a substitute. Substitute metering is the only option for small objects against the sky: birds or aircraft for example. Just make sure your substitute is in the same light that is falling on your subject.

You can use the palm of your hand (it is something you always have with you). Meter off your hand, held in front of the subject. Don't let shadows fall from your fingers and hold your palm out flat to the camera, filling the frame. Caucasian skin needs a stop more than the reading. If the meter suggests 1/125 at f/11 give it 1/125 at f/8. Brown or weather-beaten skin almost matches a grey card reading. Darker skin may need up to one stop less than the meter suggests. If the meter reads 1/125 at f/8, give it 1/250 at f/8 or stop the lens down to f/11. Find out how your skin relates to a grey card reading.

Averaging the readings taken from the shadows and highlights doesn't have to be done with a spot meter. You can move in closer and take an average reading. The correct exposure will be somewhere between the reading for the darkest and lightest areas of the subject (this does not take into account how you subjectively wish to portray the scene but it gives you a fairly objective starting point). If the meter reads 1/250 at f/5.6 for the lightest part and 1/15 at f/5.6 in the shadows, expose at 1/60 at f/5.6, which is halfway between the two.

To get guaranteed shadow detail you could alternatively expose for the shadows and compensate. Take a meter reading from the darkest area where you want detail (a cat's black fur for instance). Then make your exposure at two stops less. If the meter says 1/125 at f/5.6 use two stops less: 1/250 at f/8 taking one stop each from shutter speed and aperture in this example.

Bracketing is one way to find the right exposure by playing it safe and taking additional under- and overexposed images. Take some form of meter reading then shoot additional frames whole or half stops under- and overexposed in a series of three or five frames. Many modern cameras can expose a quick burst of bracketed images providing one- or half-stop changes in either the sequence metered-underexposed-overexposed or underexposed-metered-overexposed for three, five or seven exposures. Metered reading first is the safest option for anything other than still life. Bracketing cannot work if movement is involved, or with candid photography for instance where you get a single opportunity to capture a fleeting expression or moment.

So why not do it in Photoshop?

It is very tempting to let the camera's automatic exposure modes take control. The thought is always there that Photoshop is available to adjust and fix something that is not quite right, so get the pictures taken. Photoshop can do many things. What it cannot do is make up for data not present in the original exposure. That is what is lacking if you get the exposure wrong in the camera. It may seem like a small exposure error but problems will very soon appear when the image is adjusted, even with a RAW 16-bit image.

The issues of overexposure and blown-out highlights are now well known to digital photographers who take care not to introduce this kind of problem into their images. There is a popular belief that an underexposed photograph can always be saved. While there is some merit in erring on the side of underexposure, there are inherent problems in relying on Photoshop always to lighten up your images. For one thing, this will produce more noise in the image; it may change the colours and it will certainly produce a degree of banding. This is what happens when you run out of numbers to encode the subtle changes in colour. Take the simplest case of a subtly changing grey tone. Regularly spaced numbers changing in small steps would express a smooth tone ramp. If your data doesn't have enough numbers, when you lighten your image, big steps and long runs of the same number will appear. Visually this would look like a staircase of a few distinct levels of grey, which is known as 'banding'. (You can look at the effect by intentionally posterising an image and specifying a low number of available colours or shades of grey.)

The images on this page and opposite show a Peugeot 406 Coupé from the late 1990s, painted in a very distinctive shade of pale lemon yellow. As can be seen, photographing the car against a very light surface gives the camera a difficult target to meter.

Original shot
In Program Automatic mode the camera used for this exposure suggested 1/80 at f/4.5. This gave insufficient depth of field (first error the auto exposure made). Using the command wheel to override the suggested setting, an aperture of f/8 was chosen, the camera matching this with a shutter speed of 1/20 sec. The resulting image is comprised almost completely of tones darker than mid-grey.

With incident light meter reading
An incident light meter reading was taken of the scene and the camera switched to manual mode to record this image at 1/4 sec at f/8, a full 2 1/3 stops more than the exposure suggested by the camera.

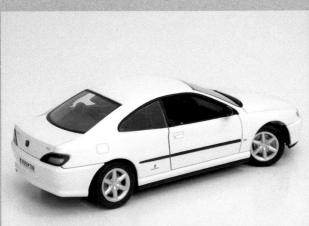

Original shot with Photoshop editing
The automatically exposed image was exported from Lightroom. Levels were then adjusted to match the tonal range of the correctly metered image in Photoshop. Any other processing was then identical for both images. At full size the corrected image looks a reasonably good match for the correct exposure – however it is a noticeably different colour.

Light detail
A closer look at the detail of the rear light cluster shows noise from the corrected darker exposure has obliterated the detail. Speckled noise is visible everywhere and eats into the detail of the 406 badge for instance. Colour changes are banded, not smooth, while the true lemon yellow colour is not reproduced.

Interior detail
A much magnified view of the dark interior of the car shows complete fragmentation of detail in noise with dreadful banding with an inky black predominating.

Dynamic range is the ratio between minimum and maximum light intensities that can be recorded by a particular photographic medium. This is usually converted to stops. Most digital cameras theoretically have a dynamic range of 10–14 stops. In practice this works out as an 8–12 stop range. The limits are due to practicalities such as small pixel size, lens flare and noise. All D-SLRs using RAW format capture give 10- to 12-stop dynamic range.

Film has different limitations, starting with the restricted five-stop (32:1) dynamic range for colour transparencies. Colour negative materials easily handle a seven-stop range and possibly up to 10 stops for some advanced colour negative films and for black-and-white films with appropriate development compensation. Latitude is a related idea and describes a film's tolerance to under- and overexposure.

This chapter looks at how to make the most of your medium's dynamic range and starts with the use of graduated neutral density filters to bring down the subject brightness range to a point where it falls within the medium's capabilities. Both film and digital photographers can use Grad ND filters. Those using digital cameras have a distinct advantage in the camera RAW file format, which gives both exposure and white balance latitude with post-production adjustment.

Digital technology offers a way around the problems of photographing wide dynamic range scenes: High Dynamic Range Imagery (HDRI or HDR). This combines a number of under- and overexposed images that together capture the shadow and highlight detail and put them into a single file. This needs further processing using tone-mapping software to match human perception and to be able to be displayed and printed.

Though originally developed for film users, the Zone System has features that digital photographers can use for exposure control. A second aspect of the Zone System, expansion and compaction of dynamic range, is applicable only to film. This section concludes with a look at changing film speed – so-called 'pushing' and 'pulling' film – and at exposure control of selective image areas – 'dodging' and 'burning' – in both the wet darkroom and using the latest software technology.

Ford Crown Victoria

Full shadow detail is revealed and local contrast enhanced for impact with image post processing.

Photographer: David G Präkel.

Technical summary: Canon G9 9.9mm (40mm 35mm equivalent) 1/200 at f/4 ISO 100. Processed with Contrast Master plugin.

Graduated Neutral Density (Grad ND) filters

When it comes to dealing with extreme dynamic range, the key item in a photographer's kit bag is the graduated neutral density filter (Grad ND). To get some definitions out of the way: neutral density means a reduction in light intensity equally across the visible spectrum. An ND filter appears grey because it cuts down light of all colours. A graduated filter is one that shows a gradual change from one density – usually clear (no density change) – to another density. The area between the clear portion and the neutral density portion has a smooth transition (graduation). Carefully positioning this over part of the scene where it will be lost, you can effectively get one exposure in one part of the image and a second exposure in the other. A Grad ND filter reduces the SBR so it falls within the limits of the recording medium.

There are two things to consider when buying Grad ND filters or choosing one for use. First, how much light does the neutral density section cut down? Secondly, how fast is the rate of change from clear to density – how long is the transition? Graduations are usually described as being soft or hard while the manufacturers specify the neutral density part of the filters as ND-2, ND-4 or ND-8, which passes a half, a quarter and one eighth of the light respectively. Alternatively, these same strengths of filter will be described as density 0.3, 0.6 or 0.9. Both mean that the neutral density section gives a one-, two- or three-stop reduction respectively.

If your histogram shows highlight clipping in the sky, or your spot meter reading for film begins to exceed six stops, you would use a Grad ND filter over the sky area. Working over water or snow you may even need two filters of different strengths with a central gap to control the brightness range.

Taking an automatic meter reading with the filter in place will make the picture too light overall. So you need to take a meter reading before fitting the filter and if the camera is in an auto or semi-auto metering mode you must use AE-lock before you fit the filter or transfer the metered shutter speed and aperture to the camera in manual mode. The best advice is to take a meter reading from a mid-tone in the clear part of the filter.

Graduated ND filter

The best graduated ND filters are the rectangular type that fit into a slotted rotating holder. They are less expensive when bought in sets. Inexpensive attachment rings match the holder to any diameter filter thread on a chosen lens. The filter can both be rotated and moved up and down so the graduation can be positioned across the image just where it is needed.

Original capture

The original shot lacks colour saturation in the sky and foreground.

Placement and extent of Lightroom filters

Sky: -1EV blue and saturation.
Foreground: -1.3EV yellow and clarity.

Morecambe Bay

Adobe Photoshop Lightroom graduated filters are used to bring life into a flat image.
A filter on the sky adds blue colour and saturation; a foreground filter brings yellow warmth to the breakwater stones, as well as increased clarity and contrast.

Photographer: David G Präkel.

Technical summary: Nikon D200 Sigma 10-20mm f/4-5.6 EX DC HSM super wide-angle zoom at 10mm (15mm 35mm equivalent) 1/320 at f/9 ISO 200.

RAW files

Digital cameras have on-board processors that are becoming increasingly sophisticated. There is, however, a good argument for taking an unprocessed file directly from the camera sensor for later processing on computer. The camera sensor produces a 12- or 14-bit file. While only 256 levels per channel are required for printing the camera sensor can record over 4000 levels. As digital photography is a game of numbers it is better to have more data than less, especially if it is to be manipulated later. Many professional cameras can produce an unprocessed file, which is described generically as a RAW format file. Many of these are proprietary modifications of the TIFF format. There is no one standard for these files and no compatibility between them; Canon files are not the same format as Olympus for instance. Each manufacturer supplies some form of software that de-codes the RAW pattern of red, green and blue data to produce a final colour image. Minilabs and commercial printers will not print from RAW files and recommend conversion to TIFF or JPEG format.

There is a range of RAW processors available that will deal with the files from every camera – though the software does have to be updated to keep abreast of new camera developments. Foremost are full-blown workflow products based on RAW format such as Apple's Aperture and Adobe's Photoshop Lightroom. Then there are products that concentrate on the RAW decoding process only, such as Bibble Pro and Phase One's Capture. There are even freeware RAW processors and increasingly computer operating systems are able to deal with RAW image files.

What is RAW? Most RAW formats are proprietary versions of the TIFF standard. Adobe DNG (Digital Negative) format, for example, is a TIFF 6.0 modification. (TIFF was originally intended as the format for desktop scanners by Aldus but is now under the control of Adobe Systems Inc who merged with Aldus in 1994.) RAW processing permits many things including de-mosaicing (turning the pattern of red, green and blue samples into colour pixels). It may store information from the camera firmware about defective or 'hot' pixels and correct them by averaging nearby pixels. (No camera sensor is perfect.) RAW processing can deal with noise and colour space conversion, converting and outputting the file in a specific resolution and colour space. It also deals with the bit-depth changes and contrast (gamma) and in some instances may have to decompress files losslessly that were compressed by the camera. White balance changes can also be applied without loss of quality.

RAW files are to a degree 'future-proof' as subsequent improvement in RAW processing software can always be applied to legacy files giving better results than did contemporary software. This is one of the reasons behind Adobe's promotion of DNG as an archival format for digital images.

	RAW	JPEG	TIFF
		Choose ISO sensitivity	
	-	Choose compression	-
	-	Choose bit depth (8- or 16-bit)	
	-	Choose image size	
Pre-shoot	-	Choose tone curve (contrast)	
	-	Choose colour space (sRGB or Adobe RGB (1998))	
	-	Set white balance	
	-	Choose amount of sharpening	
	-	Choose amount of noise reduction	

Capture	Exposure important	Exposure critical

	Colour space		
	Image size, bit depth and resolution		
	Orientation and crop		
	Shadows and highlights		
Post-processing	Brightness and contrast	Non-destructive	Anything you do tends to degrade quality
	White balance		
	Colour saturation		
	Sharpening		
	Noise reduction		

The reason for converting RAW files on your computer and not in your camera is that all the operations involved are very processor-intensive tasks. Better results come from the greater processing power of the desktop computer than from the camera's on-board processor, which is limited for reasons of power consumption and space. An additional advantage is that the original RAW file is never altered. Instead an 'instance' of that file is produced using the settings you have chosen in the RAW conversion software.

One of the most dramatic advantages of using RAW format for image capture is the ability to adjust exposure after the event. It is not something that should be relied upon as part of your everyday working practice but it is a very helpful feature of capturing in RAW. It can correct exposure errors due to metering but can also provide a degree of creative adjustment after the image has been captured – all without loss of quality. A JPEG capture has no such latitude. While it can be lightened or darkened to taste in picture editing software this is not the same as adjusting exposure with a RAW file. Adjusting exposure during RAW conversion can reveal hidden detail in shadows or highlights that are simply not present in the JPEG.

Saltburn Cliff railway
RAW format files can be used to generate a range of acceptable exposures without altering the original data.
Photographer: David G Präkel.
Technical summary: Nikon D100 28-85mm f/3.5-4.5 AF-D Nikon zoom at 28mm (42mm 35mm equivalent) 1/400 at f/11 ISO 200 RAW file instances: +2EV, +1EV, 0EV, -1EV, -2EV.

So far we have discussed adjusting exposure just as if it were camera exposure compensation – affecting the whole of the image equally. Most RAW converters offer a Tone Curve feature and this enables you to fine tune the conversion, bringing forward one area of tone while holding back another. Full-blown RAW workflow products like Aperture and Lightroom offer advanced tone control, the interactive histogram in Lightroom being a most effective way to adjust exposure, along with the Tone Curve. One of the best features is that a shaded area around the curve shows the limits for possible adjustments. You can also sample a tone in the image and adjust this directly by dragging up or down.

Adobe's Camera RAW converter has an extended highlight recovery feature that comes into operation when the exposure slider is set to a negative value. While many converters give up trying to recover detail once one of the colour channels is clipped, Camera RAW will attempt to reconstruct 'lost' highlight detail from just one remaining colour channel. How successful this is will depend on the quality of the camera model and the colour temperature settings. Adobe states: 'you may be able to recover as much as one stop of highlight detail, though one-third stop is more typical'.

Colour temperature

The same file can also produce a range of different colour temperatures (top to bottom: 3195K, 3888K, 4850K (as captured) 6250K and 8435K) though the number differences get bigger with each step the perceptual changes are constant. The green to magenta tint associated with white balance (left to right) can also be altered.

High Dynamic Range (HDR)

In the early days of digital imaging, once layering and masking were made available through advances in software, photographers began to produce composite images based on different exposures. With very wide dynamic range subjects, two exposures were taken: one that captured highlight detail and one that captured shadow detail. These were then layered and masked to produce a composite that hopefully showed detail across a wide tonal range.

High Dynamic Range Imagery (HDRI or just HDR) takes this process one stage further. It is now more usually carried out using Photoshop plugins or dedicated software that automates the process, such as the popular Photomatix Pro. A range of exposures is taken and the stack processed to produce a single composite image. This is usually in 32-bit format and requires 'interpretation' before it can be used on a computer monitor or printed. This is where tone-mapping software is used to re-map the information to more accurately match our perception of the original scene (see page 134 for more details on tone mapping). There is some confusion of vocabulary as the tag HDR gets applied to all techniques where different exposures of the same scene are used to create an enhanced dynamic range final image. True HDR outputs a 32-bit file for tone mapping while any other technique that outputs an eight-bit file is better described as exposure blending. Photomatix Pro also deals with RAW format files and offers both true HDR and exposure blending.

Exposure blending is a single-stage process as opposed to the two-stage HDR and tone-mapping workflow. It also has the advantage of reducing noise whereas HDR/tone mapping may actually increase it. Exposure blending gives immediate, natural-looking results.

HDR images can of course be generated with film cameras using just the same exposure techniques as those listed on the next page. The image sequence is scanned (turn off the scanner Auto Exposure) and the images processed in just the same manner as any digital file sequence. It is particularly important to use an 'Align images' feature if this option is available in the software. In fact, it is even possible to HDR-process a sequence of scans at different 'exposures' from a single film negative, though some experimentation is needed to set the exposure increments and a normal, light and dark scan may be all that is required.

Three individual files for HDR processing

Metered exposure

Lens flare and blurred object to left that will be lost in cropping.

-2EV exposure

Retains highlight detail in the sky, cobbles and car brightwork.

+2EV exposure

Reveals shadow detail. Figure moving in from right will be lost to some extent in HDR process.

HDR technique

For best results with HDR software, the sequence of exposures needs to include images that are correctly exposed for highlight detail and some that are correctly exposed for the shadows. Getting shadow detail is particularly important in order to avoid noise in the final HDR image.

Aperture priority mode is recommended so only shutter speed changes to create the image sequence. Changing aperture would produce depth of field effects that the HDR software could not handle, resulting in images with an overall blur. Use a low ISO setting and pick the auto-bracketing mode on the camera for three, five or seven exposures. Use the 'Continuous shooting' mode to pack the sequence in as quickly as possible and trigger the camera with a cable release, self-timer or remote control to avoid camera shake or moving the camera between exposures. As some cameras will rattle and roll in the rapid-fire mode, you may wish to fire the sequence by hand and consider mirror lock-up – anything to achieve a consistent set of blur-free images with your particular camera.

The number of exposures you take will depend on the dynamic range of the scene. Think of the extra bracketed shots as reaching out into the shadows and highlights beyond what the camera normally sees. The wider the dynamic range, the more shots you need or the further apart they must be spaced. When shooting outdoors, three exposures at the metered exposure and ±2EV will be sufficient. Dark room interiors that show a window with outdoor detail may require a sequence of nine exposures at ±1EV increments or five images at ±2EV.

Though some HDR software packages will align the component images, in my experience they need to be as pixel accurate as possible; hand-held sequences rarely align to produce a sufficiently crisp final image. Though it imposes limitations on working practice and subject matter shooting, HDR is something best done from a tripod or stable camera support. Bracketed image sequences shot hand-held on a rapid-fire professional D-SLR can make the grade.

When something moves in the image between exposures it creates a ghosting effect that can be reduced or removed – sophisticated software such as Photomatix Pro can deal with rippling water as well as simply moving objects like cars or people. However, it is best not to rely on this feature too much and create your images when the area is quiet or when there is no strong wind.

Beetle Glamour

The tone-mapped output of the HDR process has formed the basis for this enhanced image using hue and saturation layers and four locally applied contrast curves. Local contrast has been further enhanced with high-pass filtering. Each adjustment layer is carefully masked.

Photographer: Dan Deakin.

Technical summary: Nikon D50 Sigma 10-20mm f/4-5.6 EX DC HSM super wide-angle zoom at 10mm (15mm 35mm equivalent) 1/250 at f/11 with additional +2EV and -2EV exposures. Aperture Priority metering. Custom white balance. HDR processing in Photomatix; Photoshop HSL, high-pass filtering and contrast curves applied through masks.

Tone mapping

Tone mapping is a processing technique used to make an HDR image more closely match human perception when shown through a medium with a necessarily more limited dynamic range. Tone mapping deals with the massive contrast range of a 32-bit HDR image by compressing it while revealing detail in both shadow and highlights, in what is hopefully a natural way.

Some tone-mapping software will work additionally on 16-bit images as well as true 32-bit HDR-derived images, which can widen its appeal. Legacy files can be processed even when an HDR sequence was not produced. Photomatix Pro tone-mapping software is available as both a standalone application and Photoshop Plugin – its detail enhancement setting is capable of producing good results from pseudo-HDR files generated from existing 16-bit images. For a realistic looking effect the strength slider needs to be less than half-way and Light Smooth set at least to high. The gamma slider controls overall contrast. There are additional settings for micro contrast (local contrast), colour temperature/saturation and shadows/highlights control.

Even an eight-bit JPEG image can be contrast adjusted using something like Photoshop's Shadows/Highlights feature. No extra detail will be revealed, as there is none there to reveal in an eight-bit file. However, a more satisfying balance may be achieved. Between this and true tone mapping comes a new generation of contrast-enhancing software such as AKVIS Enhancer (just one of the features of this stand-alone application), Photolift (a Photoshop plugin) and Contrast Master from Harald Heim's plugin site. Using a sophisticated set of mathematical models (algorithms), Contrast Master can adjust local contrast in various ways to bring out hidden detail. Like true tone-mapping software, these are very powerful tools and all too easy to misapply.

Tone mapping itself produces distinctively painterly results if overdone and is in danger of becoming an overused 'look' in contemporary digital photography. Tone reversal, where the highlights turn darker than the lightened shadows, is a particularly ugly graphic effect.

Edinburgh skyline

A simple snapshot of the Edinburgh rooftops is brought alive by tone mapping. Texture and mood are added to the overcast sky and the stone now glows. Note how the tones are on the point of reversing – any stronger application would produce an unnatural effect.

Photographer: David G Präkel.

Technical summary: Canon G9 29.2mm (117mm 35mm equivalent) 1/500 at f/4 ISO 100 tone mapped from single 16-bit file using Photomatix Pro tone-mapping plugin.

The Zone System

The Zone System was established by the landscape photographer Ansel Adams and co-worker Fred Archer in the early 1940s and was based on articles by John L Davenport published in *US Camera* magazine. Adams wanted a series of practical tests to bridge the gap for his students between the full-on science of sensitometry and expressive photography. His idea was to be able to achieve, through careful exposure, development and printing, the tonal range you visualised in the original scene.

Simple Zone System for digital

The Zone System truly relates to printing black-and-white prints from negatives. There are, however, two parts to the Zone System: the system for exposure is suitable for all types of photography; the Zone System for compressing or expanding tonal range by development is for film only. The scale of zones has changed over the years. Modern texts use a Zone System with 11 zones from Zone 0 (unexposed film or maximum black of printing paper) to Zone X (totally black film/specular highlights in the print), only nine of which hold information. (Adams did not originally include a Zone X.) Roman numerals are used for the zones, with the interval between each zone being one stop, which is a doubling or halving of the light (luminance change). Zone V is the mid-point of the scale (mid-grey) with all usable image information falling in and between Zones I and IX. Adams referred to this as the dynamic range and to Zones II to VIII as the textural range; the range that shows real texture.

The key concepts in the Zone System are those of place and fall. All reflected light meters give an exposure reading that will produce a mid-grey (a Zone V value) at that point in the finished print. Any tone that you measure in your subject with a reflected light meter will be reproduced at Zone V. You can think of this as having placed that luminance on Zone V. If you measure a dark area of the subject and get a meter reading that is three stops lower, that luminance has to fall three zones lower than Zone V which will be on Zone II. You can place any luminance value on Zone V – and so determine the camera exposure and see where other key tones will fall. You can easily see whether you will lose image information at one end of the scale or the other and if your chosen exposure will capture the textural detail you expect.

Adams suggested using light meters with homemade Zone System scales applied. All you need is a meter that can accurately measure a small enough area containing a single tone; some camera spot meters can achieve this but a dedicated spot meter makes life easier.

To summarise, the Zone System should be seen as a progressive, evenly spaced series of print tones with the step between each zone being the equivalent of a single stop. A reflected light meter reading from a subject tone will give a correct exposure for Zone V (Zone V is mid-grey) and changing exposure by one stop up or down will move that subject tone up or down the Zone scale (place it) and all the related tones above and below will move with it (fall).

	0		Paper black
	I		Threshold - slight tonality, no texture
	II		First sign of texture. Deep but slight shadow detail
	III		Average dark materials
	IV		Average dark foliage and stone or landscape shadows. Shadow value for white skin in sunlight
	V	textural range / dynamic range	Middle grey (18% reflectance) grey card. Dark skin, grey stone and weathered wood
	VI		Average white skin in sunlight. Light stone. Shadows on snow in sunlight
	VII		Very pale skin, light grey objects
	VIII		Whites with some texture, highlights on white skin
	IX		Whites without texture. Snow in flat sun.
	X		White of printing paper

Zone System after Ansel Adams and full tonal range print showing zones

The Zone System was devised as a means by which to achieve accurate development and printing of tonal range through careful exposure. Each numeral refers to a specific Zone value.

Zone System for film

In order to deal with subjects having a wider dynamic range than the film, Adams suggested a way to compress or expand tonal range on to the negative by adjusting development. This way he could produce full-toned prints from subjects with wide subject brightness ranges or under difficult lighting conditions. (Digital photographers use high-dynamic range imagery (HDR) and tone mapping to achieve a final full-toned image in these circumstances.)

Ansel Adams had the idea in the Zone System that if you can visualise (or pre-visualise as he would have said) the tones in the final black-and-white print you can choose an appropriate exposure to put the tonal range in the real world where you want it in your finished print. The key concept is linking exposure to print tones. Though you could do this by changing paper contrast during printing, Adams favoured varying film development.

Normal film development produces negatives of a known contrast, which can be read from the slope of the central section of the film characteristic curve, which will be marked as gamma (G bar or Contrast Index (CI)). Adams referred to this as N (for normal) development. When the range of tones in the subject is greater or less than normal, development can be adjusted to take account of this. Development designed to bring down the high value by one stop is referred to as N-1 (N minus one) development, sometimes called compaction development (as it compacts the tonal range). The opposite – expansion development – known as N+ (N plus) development is more commonly used. Increasing high luminance by one zone is referred to as N+1. The table shows how to adjust the recommended development time as a percentage to achieve the required degree of expansion or compaction (some commentators call this contraction).

Scene contrast	Range in stops	Development	Adjustment to recommended development time
Very low	3	N+2	add 70%
Low	4	N+1	add 30%
Normal	5	N	as recommended
High	6	N-1	less 15%
Very high	7	N-2	less 30%

Expansion and compaction development were originally conceived for the slow, considered pace of large-format photography with single sheets of film. For roll film and miniature film (35mm) users, this only works when all the images on the film are shot in similar lighting conditions or of similar subjects. Many film users will adopt a standard N+1 development if they know the negatives will be printed on a diffuser, rather than a condenser, enlarger to compensate for its printing about one grade lower contrast.

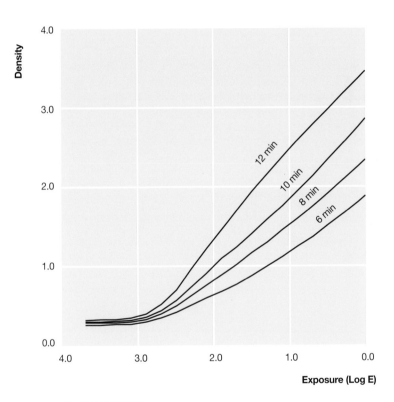

Kodak T-MAX 400

N Development

Some published characteristic curves do not show N+ and N- development but a range of curves at equal time increments. This family of curves for Kodak's T-MAX 400 shows a low contrast scene (flatly lit) can be improved by increasing development time (12 min curve with a gamma >1.0), a normal scene would be suited by eight minutes development (gamma 0.75) and a harshly lit, high-contrast scene would be best reproduced from a negative with a gamma of 0.6 developed for six minutes. Gamma (the measure of contrast) can be easily worked out like the incline of a road; how far it rises over a given distance).

Pushing and pulling film

There may be times when you want to expose the film in your camera at something other than the manufacturer's recommended speed. This may be because you want to be able to use limited available light without recourse to flash. You might wish to change either the contrast or the appearance of grain in the film you are using. This is when you need to adopt a personal exposure index and not shoot the film at the recommended ISO setting. You could for instance expose an ISO 400 film at EI 1600 if you needed the extra speed to stop motion or if you were working in low light. You would then have to compensate for the reduced exposure by increasing the development time. This is known as 'push' processing – you have pushed the speed up.

Pushing example
You have chosen to expose an ISO 400 rated film (Ilford HP5 Plus for example) at EI 1600. This means that the film in the camera has been effectively underexposed by two whole stops (the difference between ISO 400 and EI 1600). To compensate for the underexposure you must overdevelop the film with an extended development time. The visible result in the developed negatives will be an increased contrast and more visible grain.

You can also 'pull' the speed down by exposing a high-speed film at a reduced speed and giving a shorter development time to compensate. This strategy is often used to reduce the graininess of some well-loved high-speed films.

Pulling example
You have chosen to expose Kodak Tri-X Pan, an ISO 400 rated film, at an EI of 320 for later development in Kodak Professional Xtol developer. This means the film in the camera has been effectively overexposed by one third of a stop (the difference between ISO 400 and EI 320). To compensate for the overexposure you must underdevelop the film by giving a shorter development time. This will result in reduced contrast and grain. The general rules for pushing and pulling film are:

Underexposure + increased development = increased grain and contrast

Overexposure + reduced development = reduced grain and contrast

Whole stop changes (from 400 to 800, or from 200 to 100, for example) are the easiest to work out and you should follow manufacturer's instructions for development times closely, as these will take into account unwanted changes in contrast. If you use a camera with automatic film speed sensing (the DX system) you must learn to set the film speed manually if you want to push or pull film.

Film speed and grain

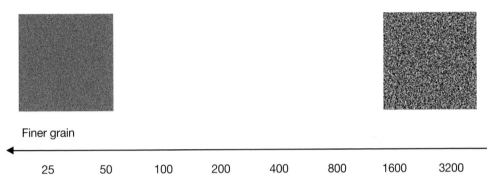

Finer grain

| 25 | 50 | 100 | 200 | 400 | 800 | 1600 | 3200 |

Lower contrast

Film speed and contrast

The effects of pushing and pulling film

The effects of pushing and pulling film will be in addition to the film's inherent qualities. In general, high-speed films have lower contrast and coarser grain than slow-speed films, which show higher contrast with finer grain. (Note: very coarse grain films may appear contrasty as their grain size prevents subtle tonal gradation.)

Local exposure control

Local exposure in the darkroom (dodge and burn)

In the negative/positive process, once an image has been captured on film there is always a second opportunity to adjust exposure during creation of the final print. Overall exposure, contrast and brightness can be adjusted during printing but more important is the opportunity to adjust exposure not on a 'global' level but on small details within the image.

An exposure that captures the overall look may block-up some detail in shadows or lose some highlights. Increasing exposure locally will darken that area of the print and bring out highlight detail. Casting a shadow – to effectively reduce the exposure received in that area – can bring out shadow detail. Reducing exposure to lighten an area is called 'dodging'. Increasing exposure is known as 'burning-in', or just 'burning'. The tools used by darkroom workers to change local exposure are called dodgers and the burning board.

Dodgers can be bought but the most useful are homemade. Wobbly, thin wire that supports a blob of Plasticine or Blu-tack, which can be moulded into any shape and attached to bits of black card or foil are best. The thin support doesn't cast sufficient shadow to show in the final print and the 'wobble' produces a smooth edge to the dodge.

The burning board is a piece of black card with a crudely made hole that can be used to increase exposure over a controlled area by moving the card around during additional exposure time.

Many darkroom workers prefer to use their hands to cast shadows to dodge or let light through between the hands or fingers to burn in. (This explains the adoption of the dodger and hand symbols for the Dodge and Burn tools in Adobe Photoshop.) The closer to the enlarger lens you work, the bigger and softer the dodge or burn. The dodger or burning board must be kept moving to blend the affected area successfully into the overall image. There are physical limits on the size of item you can successfully dodge or burn and the degree to which this can be done without the effect appearing too obvious.

In the darkroom, successful control of local exposure depends on accurate testing. It is best to produce a range of test strips that establish the appropriate dodging and burning values that depart from the overall exposure. It may be necessary to produce strips for different areas of the print. A thumbnail dodging and burning plot is often drawn – some use stop adjustments, some use times – that enables the photographer to later recreate their final print.

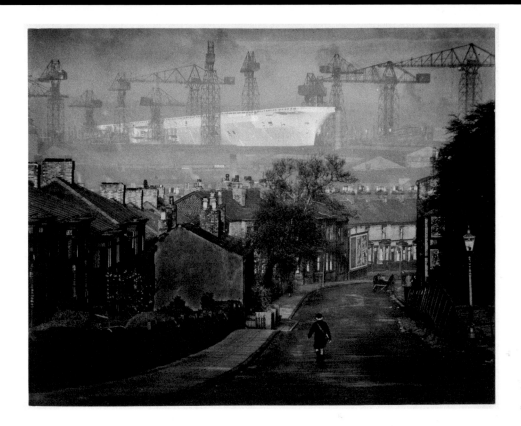

Birth of the Ark Royal (April 1950)

Classic darkroom technique to adjust local contrast.
Left: retouched positive internegative produced by contact
printing. Red dye (coccine nouvelle) has been selectively
applied as a photo-opaque material to darken the distracting
light tones and throw the emphasis onto the white painted
aircraft carrier in the distance. Above: final print cropped to
lose the closest streetlamp and clutter to the right.

Photographer: E Chambré Hardman.

Technical summary: 3 1/2 x 41/4 inch revolving back Auto Graflex
camera with Teleros 13in lens on Kodak Double X sheet film.

Control points
Control points placed in sky – top slider adjusts area over which adjustment has effect ('intelligently' based on image content). Brightness slider used to darken sky – hue and saturation not adjusted.

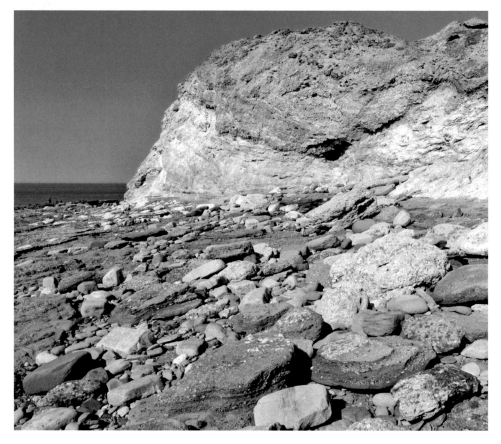

Man-made cliffs
Note that only the sky area has been darkened by the operation of the control point, the top of the cliff has not been darkened as would be unavoidable using a graduated filter (software) without complex masking.

Photographer: David G Präkel.

Technical summary: Nikon D200 18-35mm f/3.5-4.5D AF ED Zoom-Nikkor at 18mm (27mm 35mm equivalent) 1/400 at f/10 ISO 200.

Local exposure control – digital (selective area – control points)
Once an image has been converted to digital form, adjusting brightness is simply a matter
of mathematics. Adding values makes a pixel brighter; subtracting makes it darker. The real
power of image-editing software is in its ability to dodge and burn down to the pixel level.
Software dodging and burning can produce local exposure adjustment to much finer detail
than is possible to achieve in the traditional darkroom.

The Dodge and Burn tools in the Photoshop toolbox are oddly enough not a first choice for
local exposure adjustment as their operation is far from non-destructive. The main objection
is that they change the hue as well as lightness when used in RGB mode – the file needs to
be changed to Lab mode.

Advanced workers use layers for local exposure control as this is non-destructive and does
not change information in the original image. The dodge and burn layer (a 256 level greyscale)
can be stored for reference and its overall effects adjusted through Layer Opacity.

Separate dodge and burn layers can be used but a preferred method combines the effects,
which are never applied to the same image areas. A Photoshop Soft-Light layer is filled with
'Soft-Light-neutral colour' (50 per cent grey) when it is created. You can name this 'Dodge
and Burn' through the Layers palette and though it appears as a mid-grey layer over the
background image, it has no effect. However, moving pixels in this layer towards black will
darken the image beneath (burn) while moving pixels toward white, will lighten the image
(dodge). With a brush set to 10 per cent opacity you draw on the 'Dodge and Burn' layer in
white to dodge or in black for burning-in respectively. To change your mind, simply paint back
mid-grey over the mistake. If dodging and burning seem too coarse you can blur the layer
or parts of it.

Control points are an alternative software technology for applying local exposure adjustment
(being equally applicable to hue, sharpness, contrast or indeed any other possible software
adjustment). The best implementation is U Point technology featured in Nikon Capture NX
and in the Nik Software's own Viveza plugin available for Aperture, Lightroom and Photoshop.
U Point allows control points to be placed in an image that lets you change virtually any aspect
of the image without using layers and mask. The control point, once placed, can be sized and
adjusted with simple drop down sliders – its effects are then intelligently based on image
composition.

Though almost every exposure seems to turn out a 'special case' there are some circumstances notorious in the photographic world for being especially difficult to meter and capture successfully. In some situations a technically correct exposure is not what is required and there is a degree of interpretation of what makes a good image rather than a technically correct image. Exposure may have to be adjusted from what is suggested by a light meter to capture what is in your imagination.

White balance deals with the colour cast in neutral colours, like tonal distribution in an image; it is a great indicator of mood. There are times when it is not appropriate to go with the camera's recommendation but to adopt a blue or a yellow cast to suit subject or mood. Winter images in snow combine issues of exposure and white balance in one difficult-to-solve puzzle. Without knowledge of exposure compensation, what constitutes photographic daylight and an appropriate adjustment of white balance, winter images can turn out disappointingly blue-grey.

Flash has been called 'pocket sunlight' and it is certainly a convenient light source. Its effects can sometimes be difficult to judge and can dominate images if not controlled. This section looks at how flash metering works and at the sometimes-difficult subject of balancing fill flash with ambient light.

Infrared film photography has a distinctive look but the options for the analogue photographer are narrowing as films are withdrawn and manufacturers leave the market. Digital infrared photography promises to replace false colour film infrared (which is certainly no longer available) and to offer new opportunities for exploring an alternative way to see the world. Exposure issues with the necessary deep red filters and the pros and cons of specially converted cameras are discussed.

The chapter concludes with a look at 'open shutter' photography, exposure issues with close-up photography, the creation of double and multiple exposures with both film and digital cameras and how to cope with extreme lighting conditions.

Balance of nature
Rapidly changing weather and light require a keen eyeand technical confidence.
The photographer must be prepared to act quickly to capture moments such as this in Tingvellir, Iceland.
Photographer: Olgeir Andrésson.
Technical summary: Canon EOS 5D Canon EF 16–35mm f/2.8L II USM Ultra Wide Angle Zoom at 16mm 1/4 sec at f/2.8 ISO 100. Spot metering. Circular polariser. Adjusted for shadow, highlights and saturation in ACDSee Pro.

Technical versus subjective exposure

Precise measurement or calculation of exposure will certainly produce a usable image but it may not be the image you wanted or imagined. This is the difference between what is technically accurate and what is subjectively satisfying. As mood is dictated largely by the distribution of tones in that image, it may be that you need to adjust exposure to suit your taste. You can make adjustments using any of the three exposure variables. Though it is more common to change either the lens aperture or shutter speed, there are times when you would like them to remain fixed and can use the sensitivity setting to change exposure. There is also the EV compensation button, which can be used to deliberately change exposure. All these controls are there to enable you to create the image that expresses what you intend and not just to achieve a technically correct adjustment to the exposure.

When working with subjects that show a wide subject brightness range (SBR), adjusting the exposure up or down will almost certainly result in lost information at one end of the tonal range or the other. This will show as either lost highlight detail or blocked-up shadows. For scenes that have an SBR of five stops or less, there will be some latitude, making it possible to over- or underexpose the scene by up to one stop to lighten or darken the look of the image. If you don't want to alter the aperture and change the depth of field, use shutter speeds to make the change.

Working with transparency materials, it was a common habit of professional photographers to intentionally underexpose the film by half a stop to produce richer looking and more saturated colours. Early digital cameras underexposed almost as a matter of course as camera manufacturers wished to avoid blown-out highlights at any cost (the cost usually being noise in the shadows). You can use underexpose to create a richer looking digital image but do check the camera is not already underexposing by performing a grey card test (as outlined in the section on calibrating digital exposure index on pages 52–53).

Bracketing (see pages 36–37 and the comments on page 119) is a useful technique – when the subject allows – that permits the photographer to choose a subjectively satisfying exposure at leisure. It also has the advantage of showing a direct and immediate comparison with the technically correct exposure and requires no post-production work that might produce noise or other artefacts.

Summer blooms

To give the appropriate summery feel to this soft-focus image, the technically correct
exposure required considerable exposure compensation to lighten the tones.

Photographer: David G Präkel.

Technical summary: Nikon D100 60mm f/2.8D AF Micro 1/750 at f/6.7 ISO 200 +1.7EV.

Karel Holas (violinist)

Strongly backlit subjects are almost inevitable in gig photography. Subject is used to mask the brightest part of the light while lens flare is placed creatively. Choice of centre-weighted metering prevents the image from being blown out.

Photographer: Marek Sikora.

Technical summary: Canon EOS 40D Canon EF 24–105mm f/4.0 L IS USM at 24mm (38mm 35mm equivalent) 1/25 at f/4 ISO 800. Centre-weighted (partial) metering. Levels adjusted in Photoshop.

Back and rim light

Back lighting describes the circumstance whereby the light source is behind the subject. In the studio, one extreme form of backlighting is to shoot against a large softbox. Yes, that is correct: to photograph the subject directly in front of the main light source. Of course a lot of reflected light will be needed to illuminate the subject, who would otherwise be in their own shadow. Photographers attempting this technique will put the camera in a small gap between two large white reflective boards to achieve the effect.

Spot metering the subject or using an incident light reading from the subject's position (facing back to the camera) to establish and maintain a mid-tone reading is the key, and being certain that the 'background' (the light itself) is always at least two and a half to three stops brighter than the mid-tone reading. This will then give a completely clean white background; be warned there will be no texture and no tone. Digital cameras will show this as a completely blown-out highlight but the look can be very effective. The skill is in using whatever light meter you choose to set the lighting ratio between the light reflected on to the subject and that of the background itself.

If you are not using a light source as a background you may be illuminating a white background with area lighting to achieve a backlit effect. The subject may be lit by reflected light. In this instance you will need to use a hand-held incident meter to check that the illumination is even across the whole area (up and down as well as side to side). Powerful lamps and large reflectors are necessary for areas bigger than that needed for a head and shoulders portrait.

Rim lighting relies on there being a completely black background to the subject, quite the opposite of backlighting in fact, although the light source that creates the rim of light is placed directly behind the subject. At its strongest, this gives a key line of light around a completely silhouetted subject. Rim light can be used in conjunction with front lighting to create an attractive halo of light around an otherwise normally lit subject. To establish a light meter reading for stark dramatic rim lighting you need to use a hand-held incident meter. The advice usually given is to hold the meter close to the illuminated rim and to point it at the light source. This will give a minimum exposure to establish the appearance of the rim light; you may need to open up one or more stops to get the degree of bright glow required. If working with film, check the exposure with a digital camera to assess the overall effect.

If the rim light is being added to frontal lighting, a conventional reflected light meter (camera) reading may be sufficient though the bright edge may produce underexposure and some positive compensation may be required to establish a good exposure for the main subject.

White balance

White balance changes throughout the day as the light will go from yellow to white and, if overcast, to blue. Photographers have traditionally looked forward to the 'magic hour' at the beginning and end of the day when the light is richly coloured. Early digital cameras had an unnerving ability to white balance sunrises and sunsets out of existence. Though much improved in this respect, even modern cameras can mistakenly overcorrect subjects that are rich in reds and oranges as being lit by an unduly warm light source. The solutions are to either take a custom white balance from a known neutral object or to shoot in RAW and adjust colour temperature in post-production. Massive white balance corrections cannot be recommended in post-production and getting it 'something like right' in the camera should be your aim (especially if you shoot JPEGs).

Many digital compact cameras now feature sunset scene modes to overcome white balance issues. Camera automatic white balance (AWB) works best if there is a fairly bright, neutral object in the scene. If it seems that the AWB feature is not producing the results you expect first, try scrolling through the presets (Daylight, Shady, Cloudy, Tungsten, Fluorescent) to see if you prefer the look at any of these settings. White balance, like exposure, can be used as a creative tool. Advanced D-SLRs often feature white balance bracketing that produces a range of shots at various colour temperature increments rather than a range of exposures. Some professional cameras feature up to nine-shot WB bracketing with 'as metered' and 5, 10, 15 and 20 mired shift exposures towards blue and towards yellow/amber. It is actually wrong to think of this as nine independent exposures as the camera will take one 'as metered' exposure then generate and process eight copies with the required white balance shifts.

A custom white balance setting where a known neutral colour is measured by the camera and stored in a preset is the technique preferred by many professionals, especially wedding photographers who are likely to be dealing with white clothing. Even a small shift in location could produce a big change in white balance, especially in mixed lighting conditions. This is when the subject is illuminated by two or more light sources with different colour temperatures; room lights and daylight, for example. The camera's automatic white balance will calculate and average colour temperature for the scene, which may well not match your perception. Be prepared to adjust the white balance or to address the problem later during RAW conversion.

Street market under canvas

This market trader is lit by light filtering through a yellow canvas. To correct for this would make the distant daylight view far too blue. The camera automatic white balance tried to go down this route, so a custom setting was chosen instead. To help the viewer understand the scene, the composition includes part of the yellow canvas above the trader's head.

Photographer: David G Präkel.

Technical summary: Canon G9 44.4mm (178mm 35mm equivalent) 1/200 at f/4.8 ISO 100 Custom WB 4800K.

Weardale Winter

Once the correct exposure has been established for a bright subject such as this snow field (above), it does not do to overcorrect the white balance – snow should show some blue especially under partly blue skies. When white balance is 'corrected' for snow in Adobe Photoshop Lightroom, clouds become too yellow and sky loses its crisp blue quality (left).

Photographer: David G Präkel.

Technical summary: Nikon D100 Sigma 10-20mm f/4-5.6 EX DC HSM super wide-angle zoom at 10mm (15mm 35mm equivalent) 1/320 at f/8 ISO 200.

Winter weather

Winter weather delivers a double dose of photographic problems. Not only are you dealing with a white subject under what is often harsh lighting, but there are also major issues of white balance to address. Photographing snow is like photographing any other white object; if you use automatic metering without compensation you will underexpose the image by up to two stops and produce mid-grey snow. On a sunny winter's day the subject brightness range is almost certain to exceed the medium's capabilities. The job is to avoid losing highlight detail in the snow, as solid black shadows are quite acceptable in winter imagery.

Digital photographers are at a distinct advantage as they have the camera histogram for constant reference, giving them the ability to adjust exposure so it is as far right on the chart as possible without clipping white. Film, being a less linear medium, will fail in the highlights quite gracefully and is a little less critical in terms of exposure though compensation for the non-standard subject matter must still be made. Metering for a mid-tone may not capture highlight detail as the brightest whites may fall too far from mid-grey. Ideally, to get the sparkle and clarity of snow, shoot partly towards the sun and aim to get the brightest parts where you need texture to show in the snow on Zone VIII. It is best therefore to meter for white and compensate; you will need about three stops. Film users, especially those using transparency materials, need to bracket to get a range of exposures to choose from.

Winter photographs are often taken at altitude under clear skies lit by a winter sun and as such may have a much higher colour temperature (bluer) than expected. It is necessary to correct the white balance for this but you need to ask yourself an important question. How white is snow? If you correct a snow image in post-production so the snow is pure white, there is something false about the image. We expect snow to have a hint of blue, especially where it is translucent or casts shadows. Overcorrection can produce an image where other features in the image look too yellow. It is often better to look for some other neutral in the image for post-production correction; a stone or dark shadow to achieve the correct white balance. Two final tips for winter photography are to use graduated filters to create some interest in overcast skies or large areas of snow – and take enough batteries; they do not like the cold!

Flash

Flash is a reliable source of light that can be controlled by the photographer – although it can be difficult in some circumstances to judge how a final image taken with flash will appear. Advances in through-the-lens metering and wireless flash make this job much easier for today's photographers.

To be able fully to judge flash exposure you can revert to calculations based on flash unit guide numbers (film photographers with manual cameras have no alternative) or you can use a flash meter. A flash meter is designed to respond only to the brief flash of high-power light from a flashgun and not to continuous light. Flash meters also avoid the problems of reflected light as they are usually designed to measure incident light, though some advanced meters offer flash spot metering for those who prefer to work that way.

Beauty 12

Studio flash photography – a hand-held meter is used to create and control the lighting balance between the individual strobes in an image such as this. Careful metering guarantees the camera dynamic range is not exceeded and that both shadow and highlight detail are caught and placed where the photographer requires.

Photographer: Stéphane Bourson.

Technical summary: None supplied.

Flash meters can usually work either through a cord connection to the flash unit or in cordless mode. When the meter is connected (through the camera sync lead) to the flash unit, pressing the meter measurement button triggers the flash and takes a reading. In cordless mode, you simply press the measurement button on the flash meter. The meter goes into a standby mode to await a pulse of light from the flash. You trigger the flash units manually to take a reading.

Flash meters that record multiple combined flashes are particularly useful for photographers using large-format cameras with small apertures and slow colour film – especially when doing close-up work that involves bellows extensions (see pages 162–163). More than one burst of flash is often needed to provide enough light to properly expose the image. Though you can work out how many flashes you will need, it is far easier working with a flash meter that measures the contribution of each flash and displays the correct combined exposure.

As mentioned earlier, one of the easiest ways to establish a good exposure for film is to use a digital camera as a light meter – this is especially convenient for flash photography. You need a digital camera with a flash sync socket and can establish the correct exposure by trial and error. Set the shutter speed to the flash sync speed of the main camera and adjust the aperture in manual mode until you get a good-looking histogram and exposure. Transfer those settings to the main camera. Do not forget to match the angle of view of the digital camera to the main camera or the readings will be different.

Exposure equations you need for flash

guide number = aperture x distance

To calculate aperture: measure the distance to the subject. Divide the guide number of the flashgun by this distance to get the f-stop:

> Guide number – 45
> Flash to subject distance is 8m
> Aperture is unknown

> **aperture = guide number ÷ distance:**
> 45 ÷ 8 = f/5

To calculate the flash distance: divide the guide number of the flashgun by the working aperture to find flash to subject distance.

> Guide number – 45
> Flash to subject distance is unknown
> Aperture is f/11

> **distance = guide number ÷ aperture:**
> 45 ÷ 11 = about 4m

So far we have been discussing flash as the only light source. Blending flash and ambient light calls for more exposure control. Many cameras with built-in flashguns use flash to fill in shadows cast by sun behind the subject. This is called fill flash or is sometimes referred to as 'syncro sun'.

Camera TTL meters usually cope well in calculating a balance between fill flash and the ambient light though you may feel the flash has contributed too much light to the image and that its effect is noticeable. The flash power compensation button can be used to reduce flash output by a third or half stop to balance up the flash and ambient light to taste.

If you are using a manual camera and flashgun, fill flash will have to be calculated. Say for example you are using a film or sensitivity of ISO 200. With this entered on the flashgun calculator it may typically suggest an aperture of f/8 for a subject at three metres distant (remember that unlike the sun, the flash is subject to the light fall off of the inverse square law). With a hand-held light meter, take a reading of the incident light. Let's say this suggests a shutter speed of 1/125 sec with an aperture of f/8. Using the camera with these exposure settings would give a 1:1 ratio between flash and ambient light. To produce the preferred 1:2 ratio so that the flash contribution is less noticeable, the flash power needs to be reduced by one stop; its output needs to be halved. Closing the lens aperture down to f/11 will underexpose the flash by one stop. You must now compensate for the loss to the ambient light by adjusting the shutter speed, which must now be set one stop slower at 1/60 sec.

Professional photographers prefer medium- and large-format camera lenses with their leaf shutters to focal-plane shutters in 35mm and most D-SLR cameras when balancing flash and daylight. Leaf shutters sync at all speeds and allow a photographer to adjust shutter speeds over a wide range without losing flash sync. Focal-plane shutters are limited to flash synchronisation speeds of between 1/60 and 1/250 sec because the first curtain has fully to clear the film before the second curtain closes. This limits the fastest speeds at which synchronisation can happen. Some D-SLRs now use pulsed flash techniques to achieve high-speed shutter synchronisation. This can work to balance ambient light to flash at wide apertures but of course means buying or using the manufacturer's dedicated flashguns as this cannot work with studio flash or with battery power-pack strobes used for location shoots.

Fashion 17

Location flash photography – using only a large ring flash, the balance between the subject and the ambient lighting is controlled. Fast shutter speeds will make the ambient light seem darker without affecting the flash-illuminated subject.

Photographer: Stéphane Bourson.

Technical summary: None supplied.

Close-up

Getting intimate with the world is one of the joys of macro and close-up photography. An image is considered to be a close-up if it is in the range one-seventh life size (1:7) to life size (1:1). Many cameras are already equipped for this kind of photography and no exposure compensation is necessary. Given the normal provisos about reflective metering there should be no exposure problems.

Supplementary lenses that screw into the filter threads on the front of the lens do not require any exposure compensation. The best quality supplementary lenses are cemented achromatic doublets made of two pieces of matching glass that correct the problems of simple lenses such as **chromatic aberration**. The lenses are often sold in sets, usually containing +1, +2 and +4 dioptre lenses of increasing 'strength'. Lenses can even be stacked for additional magnification.

Depth of field is very shallow with macro and small apertures will need to be chosen to get any bulk of the subject in sharp focus at all. This of course means longer shutter speeds that are not ideal for magnified close work. This in turn means you need a camera support, or more light.

Keen close-up photographers and professionals turn to flash to solve this problem, employing axial lighting from ring-flashes or independently controlled macro lights. The introduction of wireless flash and through-the-lens flash metering has completely simplified exposure for close-ups.

True macro photography goes in further than the close-up. Macro is in the range 1:1 life size (when the image of the subject and the subject itself are the same size) to 20:1 (where the image is 20 times larger than the subject) in other words it is magnified. (Beyond this magnification lies photography through the microscope, sometimes called microphotography, more correctly photomicrography.)

Macro lenses that give up to life-size reproduction as standard do not require exposure compensation. Though when you move the lens away from the film or sensor plane to produce greater magnification – as you do using extension rings, bellows or a camera with built-in bellows (this relates to some medium-format and all large-format cameras) – you need to consider exposure compensation.

Chromatic aberration
This is a lens fault when the lens does not focus different colours at the same spot. There are two types: longitudinal and lateral. Longitudinal CA is corrected by lens pairs made of different glass called achromatic elements. Lateral CA shows as colour fringes towards the edges of an image; it can be corrected to some extent by computer software.

Enoplognatha ovata **female with egg cocoon**
Exposure in natural light – the harshness of direct sunlight has been reduced by using a thin plastic diffuser and a simple piece of paper as a reflector. Tiny scraps of paper, plastic and foil can be used as reflectors, diffusers or cutters with such small subjects.

Photographer: David G Präkel.

Technical summary: Nikon D100 60mm f/2.8D AF Micro 1/180 sec at f/16 ISO 100.

Just as a light source obeys the inverse square law, moving the lens further away from the film or sensor makes the projected image dimmer and reduces the effective aperture. Positive exposure compensation is always required. Of course, if the camera retains full metering functions with dedicated manufacturer's bellows or extension rings, there is nothing to adjust. However, if the bellows or extension rings break the electrical contact between the lens and camera body you will have to work manually.

Stop-down metering is the technique to employ. Modern cameras use the lens set to maximum aperture for focusing – this gives a bright viewfinder image. The lens only stops down to the taking aperture when the shutter is pressed. When there is no mechanical or electrical connection between camera and lens you may have to get a meter reading by closing the lens down to the taking aperture manually and centring the camera light meter to set an appropriate shutter speed. Be warned that some camera light meters do not like to 'see' a dim image through a stopped-down lens and may misread.

Some bellows give exposure compensation scales on the bed of the bellows themselves while some cameras with built-in bellows feature compensation scales that show how much extra exposure is needed as the bellows are extended. The necessary compensation factor can be calculated from the formula:

exposure increase = (bellows extension (in mm)2) / (focal length (in mm)2)

A bellows extension of 300mm would give a life size reproduction (1:1) with a 150mm lens which from the formula requires an exposure increase of ($300^2/150^2$) = x4 or 2 stops extra.

reproduction	magnification	exposure increase	increase in f-stops
1:5	x0.2	1.44	–
1:2	x0.5	2.25	1
1:1	life size	4	2
2:1	x2	9	3
3:1	x3	16	4

Calculating exposure compensation

Some photographers will calculate the necessary exposure compensation required for a range of bellows extensions and mark them on a strip of thick card that can be used as a ruler to measure the extension and then read off the appropriate compensation.

QuickDisc

For large-format photographers, the very best way to achieve an accurate compensation without calculation or measuring the bellows extension is to use Philipp Salzgeber's QuickDisc tool. This is a .pdf file that can be printed out and mounted on stiff card. Place the disc at the point of focus and measure its maximum diameter on the ground glass screen with the ruler to give a direct reading of the appropriate compensation factor in either time or aperture.

'...inspiration comes from the soul and when the Muse isn't around even the best exposure meter is very little help.'
Ralph Gibson (American artist/photographer)

Infrared

Choice of film sensitive to infrared is becoming more restricted. There are no longer any colour IR films available. Near-red films such as Ilford SFX, which has some sensitivity to infrared, are available. Nominally an ISO 200 film, Ilford recommends wide bracketing of ±2 stops to establish a good exposure for your own camera and working practice, and remarks that camera meters will underexpose by up to one and a half stops with red or deep red filters fitted as the meters are designed to read from a full spectrum.

True infrared black-and-white films are hard to find now Kodak has withdrawn the much-loved High Speed HIE infrared film and Konica is no longer producing film. At the time of writing, the German film manufacturer Maco was marketing a film designated 820c. Rated as an ISO 100 film it is recommended that the film is treated as ISO 25 when used with a true IR filter. Efke and Rollei branded IR films are also available. Exposure is through a very dark red filter that cuts out nearly all visible light. Filters are designated by the wavelength (in nanometres) at which they start to pass light and range from 695, which lets through some visible light, up to 1,000nm, which lets through none, by way of 715, 780 and 850nm. For film, exposure is usually done by metering the scene without the filter fitted and applying the manufacturer's recommended filter factor (see page 55).

Digital sensors are commonly fitted with filters that screen out much of the IR wavelengths. If you intend to pursue digital infrared photography seriously it would be worth considering having an existing camera modified by removal of the standard filter over the sensor and the fitting of a custom filter directly over the sensor. There are only a few firms that will carry out this modification, which will void any manufacturer's warranty, so it is best done to a pre-owned camera, or one old enough to be out of warranty.

Because you are not adding the effects of a filter over the lens plus the manufacturer's filter on the sensor, exposure times for a converted camera are much shorter. This enables the photographer to consider a wider range of subjects and to use hand-held exposures. One modifier quotes an expected exposure of 1/400 at f/8 with a converted Nikon D100 on a sunny day at ISO 200. An unmodified camera with an IR lens filter could require an exposure as long as one to two seconds and still give indifferent images. The camera meter will work as normal but as you cannot see infrared light, you cannot judge any necessary exposure compensation. The meter in the camera is sensitive only to visible light; some users of these IR converted cameras recommend exposure compensation of over a stop. As exact results will depend on the camera, the chosen filter, the subject and the weather, you'll need to experiment.

Lenses may need refocusing for IR light, whether you use film or digital (some prime lenses mark the focus adjustment with an offset red dot); this does not affect exposure.

Sunday Walk

With the increasing difficulty in obtaining infrared film stock digital photographers are producing a new generation of digital imagery.

Photographer: Ilona Wellman.

Technical summary: Nikon Coolpix 5700 and tripod at 35mm 1/2 at f/2.8 ISO 100 through Hoya R72 infrared filter. Sepia duotoned in Photoshop.

Fireworks

Careful anticipation is a key requirement whatever shutter technique you choose to try with fireworks. Inclusion of foreground illuminated by air bursts gives context.

Photographer: David J Nightingale.

Technical summary: Canon EOS 20D Canon 17–40mm f/4 L USM at 17mm (27mm 35mm equivalent) 2 sec at f/16 ISO 100. Manual exposure. Tone curve adjusted for contrast and channel mixer for colour balance; saturation adjusted in Photoshop.

Open shutter

In the earliest days of photography, exposure times were so long (due to the limited sensitivity of the photographic materials) that no shutter mechanism was employed at all in the cameras. An exposure was made simply by uncapping the lens. At the end of an exposure, which would be in the order of minutes, the lens cap was then replaced. This technique can still be useful today for certain subjects and is referred to as 'open shutter' photography.

The classic open shutter subject has to be fireworks. The most spectacular images always seem to capture a series of aerial bursts with great coloured streamers. What you are photographing is a moving coloured light source against a dark background. Rather than trying to synchronise the shutter to coincide with a firework burst, it is better to lock the shutter open and use the old lens cap trick to let the camera 'see' two or three air bursts in one image. Aperture will depend on sensitivity and though this technique will work with digital cameras, it is far better suited to manual film cameras. For ISO 100 you would be advised to use an aperture of around f/11 and a total exposure time of up to five seconds. You can only experiment, as each location will vary – especially as regards the amount of light in the foreground. You can give much longer exposure times if you are photographing just the fireworks trails against a dark sky than if you are including a cityscape, for example. Almost more important than exposure is framing, as you will have to judge how wide to compose the shot to include the aerial burst. A good tripod is essential.

Open shutter techniques can be used to paint a darkened subject with light. Night photography of buildings using flash or powerful hand torches has become popular. Because the exposures are so long, you can literally walk through the image, shining the lamp or firing the flash where you want it. Some photographers (Troy Pavia for instance, whose work was featured in my book *Basics Photography: Lighting*) use gelled flashes to build an image lit with unexpected colours. Exposure is always by experiment and experience.

Film technique exploits reciprocity failure to achieve longer exposure times of up to 10 minutes with ISO 100 materials and an aperture of f/5.6. Digital cameras have noise issues with long exposures and will turn in shorter exposure times, as they do not have the same reciprocity issues as film. Exposures up to three to four minutes at ISO 100 sensitivity should be acceptably noise-free. With any of these techniques the big issue will be battery life if the camera batteries are used to keep the shutter locked open. Though digital cameras do give immediate feedback of results it can be far easier to use completely manual camera equipment and film – or just take lots of spare batteries!

Multiple exposures

One of the earliest photographic tricks involved making an exposure of a person on one side of a piece of film, masking the other side. The mask was then swapped round and a second exposure made of the same subject. Once processed, the single image would seem to contain a picture of the subject talking to him or herself.

When you want to make double or multiple exposures without using masking, you have to consider each individual exposure as contributing to the overall final exposure. If the background is completely dark and the subjects do not overlap, then no compensation is required. However, if the image is more complex some exposure compensation will be needed to build up the correct exposure for the finished image.

It is easiest to explain and understand with a double exposure image. Each exposure will contribute exactly one half to the final exposure. So if two normal exposures are made the final exposure will be a full stop overexposed (remember a stop is a halving or doubling of light). To make each individual exposure contribute just half to the final exposure, the meter reading should be reduced by one stop. If the reading was 1/125 at f/8 then shoot at 1/125 at f/11 or 1/250 at f/8 (choose to change either shutter speed or aperture depending on depth of field and motion considerations). Calculation becomes a little trickier with a multiple exposure of three shots but there is a way to make things simpler once you grasp the principle involved.

By far the easiest way to deal with multiple exposures is to use the EV compensation feature of your camera rather than calculating exposure manually. It will depend on the number of individual exposures taken to create the finished multiple exposure image but for a two-shot multiple you simply dial in a negative one-stop EV compensation for each exposure.

Number of shots	EV compensation
Two	−1.0 EV
Three	−1.5 EV
Four	−2.0 EV
Eight or nine	−3.0 EV

As with all 'outside the norm' photography, experimentation and fine-tuning exposure through testing is recommended.

Only recently did it became possible to create double exposures in a digital camera. Cameras that offer this feature work out the necessary EV compensation using through-the-lens metering. They must be programmed beforehand with the number of shots that will be used to create the finished multiple image.

The Duplicitous Ms

Film makes double and multiple exposure relatively easy to achieve (all too easy, some photographers would say). This makes it possible for the subject to enter her own image and look upon herself.

Photographer: Raymond Ellstad.

Technical summary: Bronica C (from 1965) Nikkor-P 75mm f/2.8 1/40 at f/19 Kodak TXP 120 Tri-X Pan Pro ISO 320 exposed at EI 260. Three Speedotron strobes: Key light – soft box 45 degrees to subject camera left. Fill light – flash through umbrella – high and slightly to the right behind camera. Halo light – high right behind subject. Metered with Sekonic L-358 incident flash meter.

Extreme lighting

The most extreme condition has to be when your light meter stops working. This is when you need to know the **Sunny 16 rule**. The two extremes are of course too much light and too little. Night photography is worth a book in itself.

Photographing extremely bright light sources usually requires slow speed film and low sensitivities though there are still subjects that may require additional help from neutral density filters to cut down the light to manageable levels. Photographing flames you can rely on the camera's TTL meter, taking care to underexpose slightly to keep the colours rich. Fast shutter speeds to freeze the motion are better than motion blurred flames with lots of wasted depth of field.

When photographing light sources such as neon tubes it is important to have a long enough shutter speed to capture a cycle or two of the neon tube's emission – your eyes do not see them pulse. A shutter speed slower than 1/60 is recommended, again use slight underexposure to enrich the colour. In very bright conditions (snow and sand with strong sun) remember to compensate: up to two stops more than indicated for the sand dunes, up to three for snow drifts.

Moonlight is deceptive. It is reflected sunlight, over 400,000 times weaker than the sun at full moon. Leaving your camera to take an automatic exposure by moonlight (if your batteries last the course) will produce an image that looks as bright as daylight though the colours may be slightly odd and the blue sky full of star trails. To keep the night looking like night you actually need to underexpose. Bright moonlight is -2 to -5EV.

If you are trying night photography with film you will certainly be in the area of reciprocity failure and must follow the manufacturer's guidance for colour filtration and exposure compensation with long exposures. With long moonlight exposures (of about one hour), the moon will move and may cause shadows to ghost and blur.

Intense noonday light in equatorial regions catches some photographers out. Because of the sheer brightness most photographers and their subjects take refuge in the shade that, somewhat surprisingly, is intensely blue (10,000-12,000K) and requires major white balance compensation.

Sunny 16 rule

If you don't have a light meter, use the 'Sunny 16' rule. In bright outdoor light with crisp shadows set the lens to f/16 and the shutter speed to one over the film speed (sensitivity). So if you are loaded with ISO 125 film shoot away at 1/125 at f/16. (As a UK resident I tend to use f/8 at the first appearance of shadows and f/11 for soft-edge grey shadows!)

Aurora at sunrise with stars

Some low-light subjects need the extra sensitivity of a hand-held meter but this subject just falls at the lower limit of the camera meter sensitivity of -1EV. The exposure of eight seconds is well within the reciprocity range of the film and no compensation was required. Sometimes a subject will be too dark for any meter to register and exposure must be estimated from a table or a series of bracketed exposures.

Photographer: Jim Reed.

Technical summary: Nikon N90 Nikkor 50mm f/1.8 8 sec at f/1.8 ISO 100 Fuji Provia 100F Matrix metering.

Conclusion

Poor exposure will rarely give rise to a good image. All that the sophistication of the modern camera light meter produces, in the end, is an exposure combining a selected shutter speed with a selected aperture. 'Scene modes' and automatic exposure may be convenient but they are not magic and they reflect an acceptable preordained view of your world. They show the camera manufacturer's view, not yours.

Photographic self-expression is being able to manipulate exposure to your own ends. Without control of shutter speed you could not choose to freeze motion or to blur it. With control of lens aperture you can direct your viewers' attention where you want it, revealing or hiding just as much as you wish in your image. Deliberate adjustment of exposure to produce light or darkened images can dramatically alter their mood. This is part of the language of photography. To be fluent in photography you need to take charge of your camera. On occasions this will mean choosing complete manual control, at other times it is enough just to oversee the automatic functions. Professional photographers will candidly admit to using automatic exposure and focusing most of the time. They would be mad not to. They do, however, understand how the camera is working for them and are prepared to intervene in a moment to override the automation to get the right exposure.

Though film is now a costly medium (at least compared on a picture by picture basis with digital) it is also a considered medium that at times rewards a slow and deliberate approach. The arrival of digital photography removed many of these constraints, though this can lead to a frantic photographic free-for-all with an approach summarised by: 'I'll fix it in Photoshop.' There are far better things to be doing in Photoshop than fixing a poor exposure. Digital technology should encourage experimentation with exposure, though this should not be allowed to expand into an unconsidered proliferation of images for later editing, none of which turn out to be suitable on the grounds of content or technique. Photographic creativity cannot always rely on serendipity.

Digital processing offers new ways round traditional photographic limits, widening the dynamic range that can be captured and printed for instance. But digital's great gift to photography is the opportunity it provides for cost-free experimentation. Hopefully, this can lead to an understanding and demystifying of exposure. The key for all photographers, however, is to understand reciprocity – exposure's give and take between intensity of light and duration – and to treat exposure as a friend not an enemy.

Contacts

Stéphane Bourson
www.sbourson.com

ContrastMaster
www.thepluginsite.com/products/photowiz/index.htm

David J Nightingale
www.chromasia.com

Nik Software
www.niksoftware.com

David G Präkel
www.photopartners.co.uk

Jim Reed
www.jimreedphoto.com

Philipp Salzgeber (QuickDisc)
www.salzgeber.at/disc/index.html

Sekonic
www.sekonic.co.uk

Marek Sikora
www.mareksikora.com

Patrick Smith
www.patricksmithphotography.com

Adrian Wilson
www.ade_mcfade@yahoo.com
www.mcfade.com

Aperture
Variable opening in the lens controlling the intensity of light reaching the film or sensor.

Banding
Description of the visual effect of posterisation where abrupt changes in colour produce the appearance of coloured bands in what should be natural and continuously changing tones; this is usually because of exaggerated changes in contrast producing insufficient levels of tone to convey a smooth gradation.

Characteristic curve
A graph that shows the relationship between the amount of exposure given to a photosensitive material and the corresponding density after processing.

Chromatic aberration (CA)
This is a lens fault when the lens does not focus different colours at the same spot. There are two types: longitudinal and lateral. Longitudinal CA is corrected by lens pairs made of different glass called achromatic elements. Lateral CA shows as colour fringes towards the edges of an image; it can be corrected to some extent by computer software.

Contrast
The difference in brightness between the darkest and lightest parts of the image.

Densitometer
An instrument used to measure the optical density of a negative (transmission) or a print (reflectance). Used for calibrating the development and printing processes.

Exposure
Combination of intensity and duration of light used to allow the right amount of light to reach film or sensor to record full tonal range.

Fast and slow
Subjective terms for film that reacts quickly or slowly to light (usually coarse grained and fine grained respectively). Fast means high, slow means low ISO number.

Film speed
How 'quickly' film reacts to light – a measure of light sensitivity. (See 'Fast and slow' and ISO.)

Graduated filter
Partly toned resin or plastics filter with slightly more than half of the filter clear. Clear to grey area has a smooth transition. Used to darken skies or control contrast.

Grain
Appearance in the final image of the individual specks of silver from the film negative that make up the tones of the picture.

Grey card
Standard piece of plastic or card that reflects 18 per cent of the light falling on it to provide an exact mid-tone light reading.

Illuminance
A measure of the intensity of the light falling on a surface per unit area.

Intensifier
Chemical used to increase film negative density by adding silver or altering film silver with selenium or chromium salts (uranium was once popular!). Used as a last resort to make an underexposed or underdeveloped negative printable.

Iris
A mechanism between the lens elements comprising flat overlapping plates that can be adjusted to change the size of the hole – or aperture – at its centre. This is used to control the intensity of the light passing through the camera lens and is homologous to the iris in the human eye.

ISO/ISO number
International Organization for Standardization – body that sets standards for film speeds and matching digital sensitivities.

Key
Mood of an image (usually portraits) expressed in the tonal balance. High-key images are composed largely of light tones; low-key composed largely of dark tones but both have full tonal range and are not the same as over- or underexposed images.

Latitude
The degree of over- and underexposure that the film or digital sensor can accommodate and still provide an acceptable image.

Light meter
Device used to measure the intensity of light for photography, expressed as a combination of shutter speed and aperture or a single Exposure Value (EV) number for given film speed or digital sensitivity. Measures either the incident light or the light reflected from the subject. Some additionally measure light from photographic flash.

Luminance
Measure of luminous intensity per unit area of light; describes the amount of light emitted (or reflected) from a particular area (technically defined as that falling within a solid angle). In less technical terms, a measure of how bright the surface will be perceived by the human eye.

Neutral Density (ND) filter
A filter that reduces light intensity equally across the visible spectrum.

Noise
Out-of-place pixels that break up smooth tones in a digital image. Can be colour (chroma) noise or luminance (luma) noise or a combination.

Overdevelopment
To exceed the recommended development – film left in developer for too long, with developer that is too strong or too hot. Beyond increased (N+1 and N+2) development.

Overexposure
Images created with too much light, having no shadows or dark tones. (See Underexposure.)

Photosensitive
Substance or device that reacts to visible light, sometimes also to light above (UV) and below (IR) the visible spectrum.

Post-processing
Also post-production – a general term referring to any work done after the photographic image has been created.

RAW file
Camera RAW or RAW format files come straight from the digital camera sensor without first being processed by the camera. RAW files feature 12- or 14-bit resolution permitting non-destructive editing, exposure and white balance latitude.

Reciprocity
The inverse relationship between the intensity of light and its duration reacting with photosensitive materials to create an exposure.

Reflectance
Measure of the proportion of light falling on a surface that is reflected. (See also Grey card.)

Rim lighting
Special case of backlighting where light spills around the edge (rim) of the subject from a light source hidden behind or to one side of the subject. Without frontal light this produces a key line around the silhouetted subject; with light from the front, a rim light produces an attractive glowing ring of light around the subject.

Shutter speed
Time for which the film or sensor is exposed when a picture is taken.

Subject Brightness Range
Range of light-to-dark tones presented to the camera by the subject; the combination of subject contrast and lighting contrast.

Telephoto
A type of long-focus lens with an optical design that means it is physically shorter than its optical focal length. Telephoto lenses have narrow angles of view and give cropped and magnified images.

Tone
A full range of greys from solid black through dark greys, to mid-grey and light greys to pure white. In printing it means tones that are produced by using patterns of black (or coloured) ink dots on white paper and may be referred to as a percentage.

Underdevelopment
To give less than the recommended development – film removed from developer too soon, developer that is too cold or too dilute. Shadow density in negatives may be too low producing blocked-up shadows in print. Not the same as minus development (N-1, N-2) which relies on slight exposure increase to compensate.

Underexposure
Images created with too little light, no highlights or light tones. (See Overexposure.)

White balance
Adjusting for the colour temperature of the illuminating light, so white and neutral colours appear truly neutral and do not show a colour cast.

Acknowledgements

Again, I have to thank Brian Morris and Caroline Walmsley for extending this series of books and inviting me to write on this important topic. Thanks also to my editor Leafy Robinson, to Helen Stone for picture research and to Chris Weston for reviewing the content in its early stages.

Thanks to Chris Bennion of Johnsons Photopia Ltd for the loan of the Sekonic light meters featured throughout the book. Thank you also to Harald Heim (The Plugin Site), for help with the PhotoWiz ContrastMaster plugin and to Solveig Siewert of Nik Software GmbH for help with Nik Viveza.

As always I owe an immense debt of gratitude to my wife Alison for her support, suggestions and proof-reading.

Image credits

Pages 3 and 150: Marek Sikora.
Page 32 (below): David J Nightingale.
Page 32 (above): Crisis Reverse Graffiti Campaign 2008 – to raise awareness of hidden homelessness <www.crisis.org.uk>. Artist: <moose@symbolix.com> / <www.symbolix.com>.
Page 35: John Green.
Page 47 (monochrome): Photographer: Caroline Leeming. Stylist: Amy Bannerman.
Page 47 (dark background): Photographer: Caroline Leeming. Stylist: Lynne McKenna.
Page 54: Patrick Smith.
Page 56: © Robert Doisneau/RAPHO.
Pages 64 and 65: Photograph by Jacques Henri Lartigue © Ministère de la Culture – France / AAJHL.
Page 66: Photo by Murdo Macleod.
Page 69: © Stefan Steinert, Essen. Estate Otto Steinert, Museum Folkwang, Essen.
Page 81: Mike England.
Page 86: Chris Steele-Perkins/Magnum Photos.
Page 88: Adrian Wilson.
Page 98: courtesy of Nikon.
Page 103 (beach): Howard Angus.
Page 103 (puffin): Ron Thomas.
Page 103 (model): Ron Thomas, model: Katie, ARC Studios.
Pages 131 and 133: Copyright Dan Deakin.
Page 143: © NT/E Chambré Hardman Collection.
Page 146: Olgeir Andrésson.
Pages 156 and 158: Stéphane Bourson.
Page 165: Ilona Wellman.
Page 166: David J Nightingale.
Page 169: Raymond Ellstad.
Page 171: © Jim Reed.